PORTF

That Sell

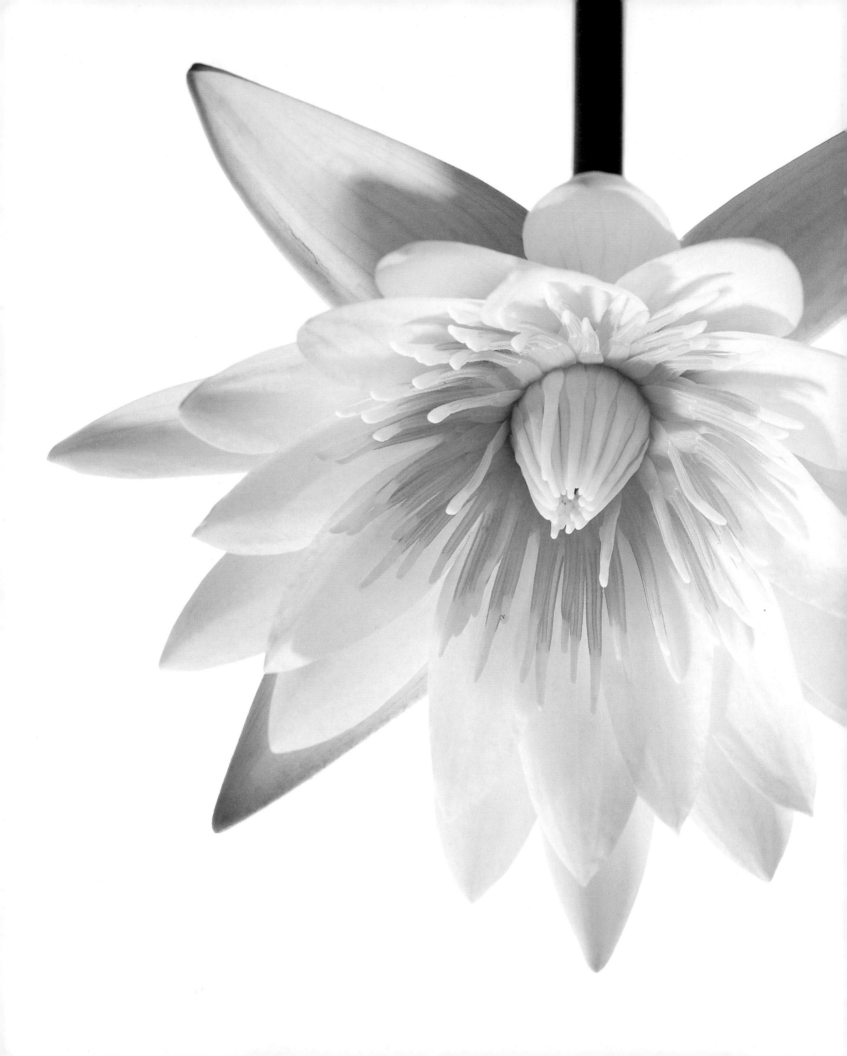

PORTFOLIOS
That Sell

Professional Techniques for Presenting and Marketing your Photographs

May 2004

For Rena
Hope You enjoy
the Book!

Selina

Selina Oppenheim

Amphoto Books

an imprint of WATSON-GUPTILL PUBLICATIONS/NEW YORK

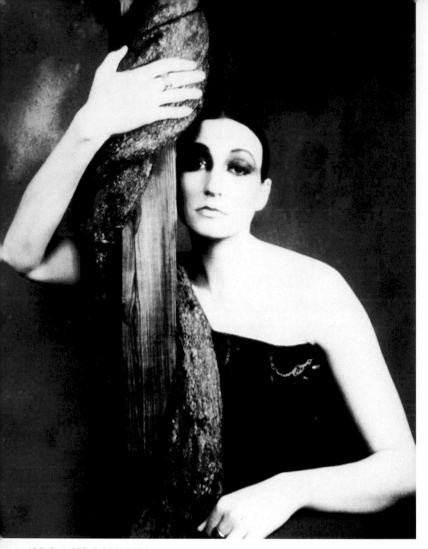

ABOVE © STEVE BEGLEITER
HALF-TITLE PAGE © RENÉE COMET
TITLE PAGE © BILL STEELE

Selina Oppenheim is one of the first consultants

for visual professionals in the country. She has over 20 years of experience working with photographers, graphic designers, and illustrators. Through her marketing firm, Port Authority, (www.1portauthority.com) she creates and facilitates strategic programs that enable clients to build businesses around their individual creative, and financial goals. She is also a frequent writer and lecturer on the topic. Ms. Oppenheim lives in Acton, MA.

DEDICATION

Portfolios That Sell is dedicated to Paula Duva, my mother-mentor, my friend, and my co-worker. Paula has sat side by side with me for the last 20 years. Her intelligence, warmth, humor, and patience are a gift that every person should experience.

As I wrote this book, Paula helped me unconditionally. She read chapters, spell-checked, and organized the search and collection of all of the imagery used in the following pages. Without Paula, this book and my life would be far less complete.

First published in 2003 in the United States
by Watson-Guptill Publications,
a division of VNU Business Media, Inc.,
770 Broadway, New York, NY 10003
www.watsonguptill.com

SENIOR EDITOR: Victoria Craven
EDITOR: Jacqueline Ching
DESIGN: pink design, inc.
PRODUCTION MANAGER: Ellen Greene

Library of Congress Cataloging-in-Publication Data
Oppenheim, Selina.
 Portfolios that sell : professional techniques for presenting and marketing your photographs / Selina Oppenheim.
 p. cm.
 ISBN 0-8174-5543-4
1. Photography--Marketing. 2. Commercial photography. I. Title.
 TR690.O67 2003
 770'.68'8--dc21
 2003002249

First printing, 2003

Manufactured in Great Britain

1 2 3 4 5 6 7 8 9 / 10 09 08 07 06 05 04 03 02

Contents

Acknowledgements

PORTFOLIOS THAT SELL HAS BEEN IN DEVELOPMENT THROUGH-OUT THE ENTIRE 25 YEARS OF MY CAREER CONSULTING WITH VISUAL TALENT, SO THERE ARE MANY PEOPLE TO THANK. WITH A VERY LARGE AND OPEN HEART, I GIVE THANKS TO:

- The photographers whom I have worked with over the years, and who gave me their trust as I sought to develop new portfolios with them.

- The photographers who generously offered their images for this book. The images within represent the work of today's top talent and are excellent examples of the information described.

- Ellen Gish, for writing a superb, on-the-mark foreword.

- Bill Smith, my dear friend, who kept telling me to write the book, and who provided enormous support and guidance as I wrote and edited.

- Victoria Craven, whose confidence in me was very much appreciated.

- Jackie Ching, whose patience and kindness are a true gift.

- Scott Miller for helping me archive the visuals.

- George Fertita, for showing me professional portfolios for the first time, many years ago.

- Pam Edwards, Susan Wilson, Tom Petit, Marty Hassell, Jack and Bill Carruthers, and my NESOP (New England School of Photography) family for providing me the opportunity and support as I taught hundreds of photography students about portfolios, business practices, and marketing techniques.

- Al Fisher, for giving me my first opportunity to work with a truly talented visual professional.

- The fabulous women in my life, for all of their friendship, love, and laughter: Diana Martin, Sage Peterson, Jenny Gulliver, Jane Ceraso, Pamela Marcus, Laura Mowers, Robin Talkowski, Siddiqi Heather Ray, Claire Newman, and "Auds."

- My guys, who have always been there in spirit: Marc Norberg, Bill Smith, Bob Mutascio, Jay Penni, Mike Howell, Mark Anderson, and the wonderful Mel Michael.

- My teachers, Bonnie Carson-DiMatteo and Janice Hope Gorman, for continually providing me an opportunity to become the valley.

- My family: my beloved boys Jake and Sam; their dad, Ed; Ed and Selma; Rob and Michele; Gisela; Carol and Dave; Jeanne and Danny; Tobi and Jerry.

- My mother for sharing an incredible sense of integrity, fairness, and a love of books.

- My Dad for sharing his love of life.

- And finally, I give my thanks to God, who has provided me with a career that I continue to love enormously, clients who become friends, and a pulpit in which to share my truth.

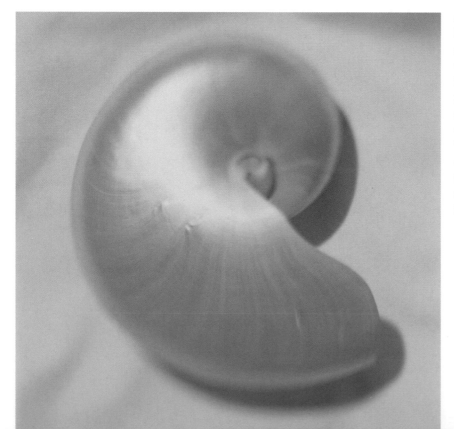

LEFT AND OPPOSITE PAGE Earl Kendall is a still-life photographer based in Minneapolis and repped by Robin Ogden. Since creating a vision-based portfolio and tearsheet book, Earl has watched his business grow steadily. His images are simply stunning. A sample is seen here. He chose an area to explore and worked very hard to develop a consistent vision. Whether shooting a still photo such as the shell, or illustrating with people, Earl makes it easy for clients to match him with projects. The quality and feel of the visuals they will receive is very apparent. © EARL KENDALL

Foreword

When Selina Oppenheim asked me to write the foreword for her book, I reflected on what I have to contribute to a book by such a well-known and respected photography consultant. To that end, I realized that I have been involved in the process of critiquing images for over 25 years, first as a photographer, then as a rep and producer for several photographers/studios, and currently as Creative Services Buyer for Target, one of the largest discount retail organizations in the United States. During this time, I have viewed hundreds of portfolios, and thousands of images, evaluating and looking for a glimpse of the photographer's way of seeing, his or her creative vision.

I have found that there is one question that plagues all commercial photographers. How do you put together a portfolio of work that successfully wins projects, gains new clients, and ultimately moves the photographer toward his or her professional goal?

Recently, I participated in a panel for the American Society of Media Photographers, made up of art buyers from different segments of the industry. We answered questions and discussed with photographers what we look for when reviewing portfolios. The moderator asked the question: "Can a photographer afford to specialize?" All of us on the panel unanimously answered: "Can you afford NOT to specialize?"

For many years, the trend has been for photographers to market themselves as generalists. In order to develop a strong and varied client base, photographers positioned themselves as jacks of all trades. Afraid of an often-volatile marketplace, they sought to service clients in as many areas of business as possible. Often their portfolios showed several areas of work, from product to people, studio to location. Photographers worried that if specific types of work weren't covered in the portfolio, they wouldn't be seriously considered for a project. Today they remain fearful, although the market has changed dramatically.

With an ever-increasing number of photographers entering the marketplace, and a wider variety of affordable stock sources available, today's buyer is no longer looking for a single photographer to meet all his or her needs. Clients are now viewing an increasing number of portfolios looking for the creative vision and the passion of the photographer. The photographer's portfolio must communicate that vision in such a way that separates his or her work from that of all the others in the process.

OPPOSITE PAGE AND ABOVE © EARL KENDALL

Cost or distance rarely influences the selection of a photographer. What matters is finding a photographic point of view that matches the creative vision of the project. As an art buyer, I have access to countless publications, and receive virtually thousands of promotional pieces each year from photographers all over the world. One image can have the power to excite me in such a way that I will call in that portfolio for review. Once I have received the portfolio, each image in the book must authenticate that creative vision.

Whether there are 6 images, or 60, each one must give me a consistent, pure glimpse into that photographer's way of seeing. Each image must communicate as strongly as that first image. If there are inconsistent or weak images in the book, they only serve to weaken the total vision of the portfolio. A truly passionate portfolio virtually begs me to find a project for that photographer.

As photographers continue to wrestle with the concept of specialization, clients continue to become more discriminating. The photographic marketplace is no longer a local, regional, or even a national marketplace. It is a global marketplace in which each photographer must choose the level at which to compete. Photographers must, therefore, find the means to focus their creative vision, and communicate that vision. It is my thought that a photographer is rarely capable of doing that on his own.

Each photograph is like a child born out of a creative labor. Though some photos are more successful than others, most photographers cannot manage to leave out the weaker images. That

is why I believe that a book of this kind, written by a consultant with such tremendous experience, is so necessary for every photographer seeking to advance in this creative industry.

Selina Oppenheim has worked as a consultant to photographers for over 25 years, helping them to determine their creative, financial, and professional goals. She has worked closely with some of the top shooters in the industry from all over the United States, as well as Canada, Mexico, and London. With her company, Port Authority, Selina has given professional business seminars, portfolio reviews, and presentations. In this book Selina shares her experience and expertise with you. She goes in depth into topics such as identifying your market; developing and focusing your creative vision; "packaging" that vision in a portfolio; and then presenting that portfolio both in a sales call and in a portfolio drop-off. Selina will help you successfully navigate the marriage between creative vision and commerce.

It has been my experience that those photographers who successfully identify, hone, and market their way of seeing have found not only financial success, but also greater happiness in the craft. I believe that a portfolio with a strong and consistent creative vision reflects the passion of the photographer. Those images are the ones that come from the heart, and the creation of those images is what will give you the greatest pleasure. I believe that in these pages you will find the information that can help to lead you toward not only professional success, but also greater happiness. Enjoy!

ELLEN GISH

BUYER, CREATIVE SERVICES
TARGET CORPORATION

Introduction

The portfolio has always been a photographer's most important selling tool. It has also been the subject of many questions and misconceptions. As a consultant for the past 20 years, I have worked with hundreds of clients on crafting their portfolios.

I continually hear the same questions: What do I put in? How many pieces should I include? Is this image too old? I don't like this image, but do I need to show it anyway? What if I like it and no one else does? What format should I use?

Photographers have lots of questions about the specifics of a portfolio, and often, in the quest for answers, they lose sight of the three main messages that it should deliver: What the photographer does, how he does it, and why the client should trust him to do the job.

Most photographers show around one book, and that same book gets reviewed over and over each time a client calls. If the book is a fit, fine. If it isn't, the job goes elsewhere.

I remember a photographer who developed his book by reacting to the comments he received. Each comment sent him scurrying back to his studio to change the images. Clearly this method of portfolio development is backward and usually unsuccessful. Happily, photographers are learning that the opinions of others fill neither their souls nor their pockets.

If you recognize yourself here, commit to changing your process. This way of selling shows a lack of commitment to developing your vision and a casual attitude to meeting clients' needs. Today's photographers cannot afford to sell in this manner. Assignments may be few and far between and competition is fierce. A strong portfolio can get you higher fees and more assignment opportunities, and more importantly the ones that fulfill you creatively.

It's okay to listen to the advice of others, but you must choose your own direction. Instead of creating a portfolio just by shooting what you like, or what you think viewers want, develop a plan of action. Take responsibility for your choices. The visual direction of your portfolio is the biggest choice you have to make. It is the beginning of constructing your plan.

In the course of this book, you will learn how to build your portfolio from the vision outward and how to create a gallery book and a tearsheet book.

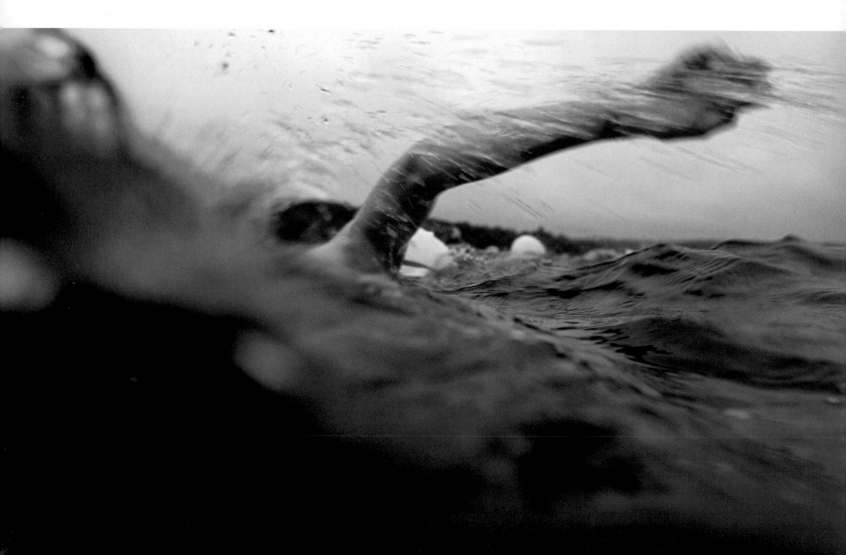

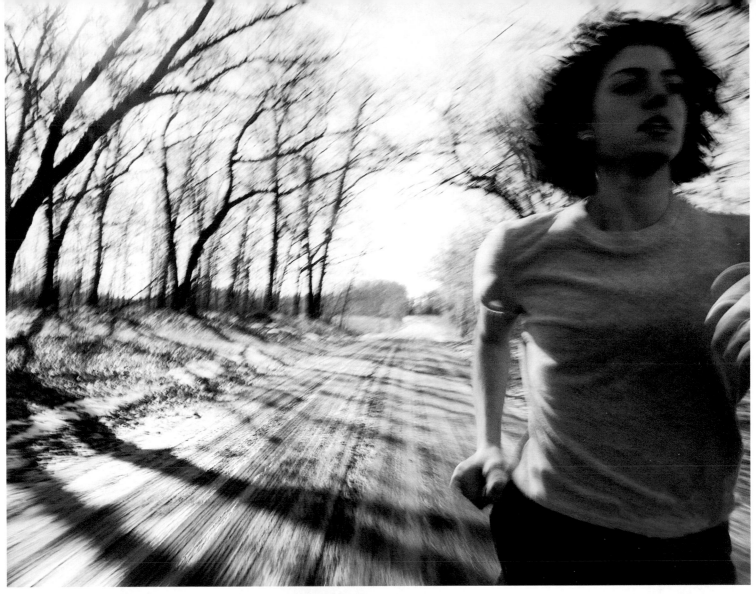

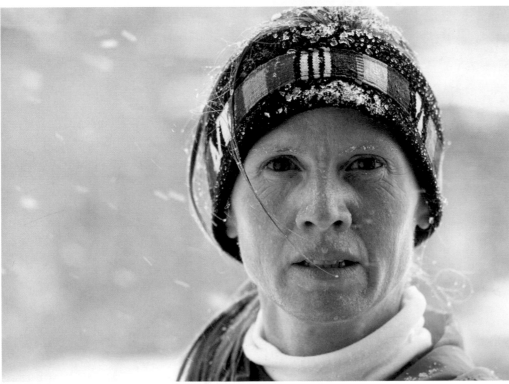

Joel Sheagren's new portfolio shows how he applies his vision toward outdoor lifestyle photography. His sophisticated portraits and moody scenes are perfect for the national advertising accounts of such companies as Columbia Sportswear, Eastpak, and Polaris. He shoots with 35mm and pinhole cameras.
© JOEL SHEAGREN

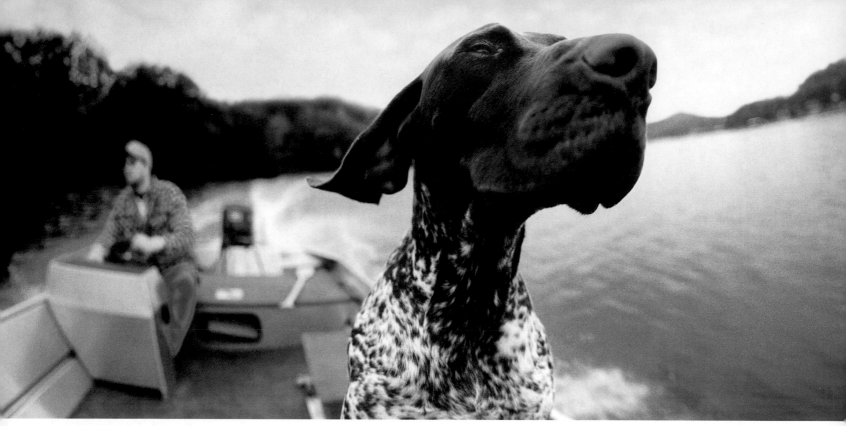

ABOVE AND BELOW © JOEL SHEAGREN

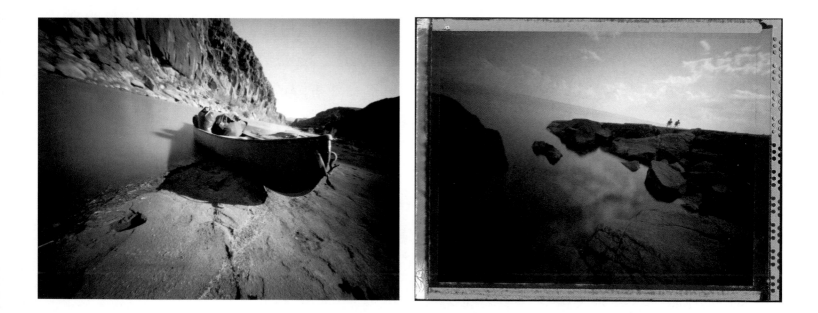

understanding the CLIENT'S NEED

You need your portfolio on two occasions. First, when you proactively seek work by sending your portfolio around to art directors, graphic designers, photo editors, and corporate communication directors. Second, when a client calls it in for a specific assignment.

Today, many photographers can create a portfolio that is representative of their vision, but not one that sells. I've often heard photographers say, "If another person tells me that they like my vision, but they don't know how to use it, I will scream."

Are clients trying to be difficult? Are they just contrary by nature? No. What they are saying is, "Show me something different and unique, and make sure I can use it." In essence, they are giving you permission to explore, to experiment, to develop your *visual integrity*, or your unique way of seeing, with the expectation that you understand what is commercially viable. It is this marriage between art and commerce that your book must speak to.

Buyers no longer look just for technical ability. They search each portfolio for *visual value*, a strong, singular style that has been defined and refined. That visual value should be seen in different applications throughout the portfolio.

You need to understand how clients make their buying decisions, and that today's buyers have many choices, from stock photography to royalty-free images. Today's clients base their decisions less on personal relationships with photographers and more on the visual demands of the project. When browsing through portfolios, a buyer is looking for the one that can communicate a clear, specific, and focused message.

Your portfolio should communicate the clear, specific, and focused message you want to send. It will take you approximately 4–8 months to complete your new, vision-based portfolio.

The photographers chosen for this book come from many different geographic areas within the United States, and they represent different disciplines of photography. Some of them have achieved national recognition (Marc Norberg, Marc Hauser, Carol Kaplan, Francine Zaslow, Michael Grecco) and some are just beginning their quest. Others came to me with successful businesses and chose to reposition or expand their work (Joel Sheagren, Mark Beckelman, Jake Armour, Debbie Tam, Patrick Prothe, and Bill Steele). They are connected by their commitment to creating portfolios that sell—a commitment that I invite you to share.

ABOVE © ZAVE SMITH

Zave Smith's new portfolio, developed over six months, was geared toward advertising art buyers who were in need of visuals that spoke to happiness, joy, and a sense of connection, concepts that they frequently build campaigns around. This portfolio repositions Zave from a still-life shooter to a lifestyle shooter. Zave has seen the first year of his marketing efforts pay off. In a year that was difficult for many photographers, Zave had his best year ever. © ZAVE SMITH

Developing Your Visual Integrity

"GREAT ABILITY DEVELOPS AND REVEALS ITSELF INCREASINGLY WITH EVERY NEW ASSIGNMENT."

–BALTASAR GRACIAN (1601–1658)

Visual integrity is your individual, unique way of seeing. It enables the client to look at the portfolio and make a direct connection between the images in it and the current assignment. A portfolio with visual integrity sells. Without it, your book will not be remembered.

It is especially important when you are sending your portfolio around cold. It sets the tone for the direct mail, sourcebook ads, website, and other marketing tools you create (see Chapter 12). It's what attracts the art director's attention, and creates a need for her to keep your mailers and consider you for future assignments.

To illustrate, here are two talented still-life photographers with the same client base, national advertisers. For clients, they are two completely different visual choices. What distinguishes them from each other are their unique visions, which, as you see here, are strong and consistent. Their portfolios possess visual integrity.

BELOW AND OPPOSITE PAGE Bill Steele creates bold, graphic, colorful images that grab the viewer's attention. Whether photographing the Gap blue jeans or pink paint dripping, Bill shoots close and big, using the object as a design element. His main tools are a strong concept, composition, and color. Clients use his dynamic imagery to draw the viewer into their advertisements. © BILL STEELE

LEFT, ABOVE AND OPPOSITE PAGE Francine creates quiet, elegant images that are concept-oriented, often combining a product and an organic element. She uses a color palette that includes soft tones of browns, greens, and blues. The overall effect is a sophisticated one. These intriguing visuals force viewers to take more time to digest them, and as clients know, this helps to sell products or services. Thus, the enigmatic quality of these images make them perfect for the advertising or corporate client. © *FRANCINE ZASLOW*

Used for a Pepsi ad in Russia. © *MARC HAUSER*

Used for a Pepsi ad in Russia. © *MARC HAUSER*

working YOUR PORTFOLIO

There are two reasons to use your portfolio. First, you can use it as a marketing tool, when no jobs are pending and you're simply sending your book out to a prospective client in the hope that he will consider you for future assignments. Second, you can use it as a sales tool, sending it in response to a request, when the prospective client has an assignment in mind (see Chapter 12).

WHEN A PROSPECT LOOKS AT YOUR BOOK, HE WILL ASK THESE QUESTIONS, THE SAME ONES YOU SHOULD ASK YOURSELF:

− Does the photographer have a well-defined vision?

− Is that vision communicated in different ways throughout the portfolio? For instance, does the photographer use different subjects and techniques?

− Are the images consistently strong in expression and technique?

− What types of assignments would I hire this photographer to shoot?

Today's buyers look for a photographer's creative input. They want to get the most value. For them, a vision that is clear, focused, and well executed is value. Photography is not just about shooting people and objects, it's about seeing in an illustrative, interpretive way. Illustrative photography captures a mood or expresses a lifestyle in a way that catches the viewer's attention, presenting products in a creative, new light. Today's art buyers are aware that this is a powerful way of delivering a message.

Yet photographers often complain that buyers are not using illustrative photography in their ads or collateral materials (such as brochures, annual reports, stickers), but that they are using literal product shots. As you can see in the images on these two pages, the opposite is often true.

Marc Hauser, one of the premier portrait photographers, proves that clients can get their message across through illustrative photography. These five images were all used for ads and collateral pieces in this country and abroad. As you look at them, note how Marc's single vision was applicable to a range of products.

Used for Agfa. © *MARC HAUSER*

Used for Ivory Snow. © *MARC HAUSER*

Used for the Polaroid Corporation. © *MARC HAUSER*

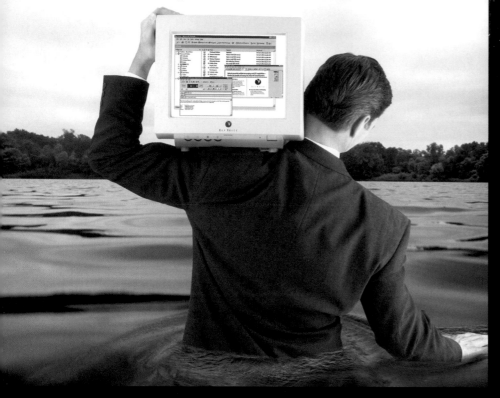

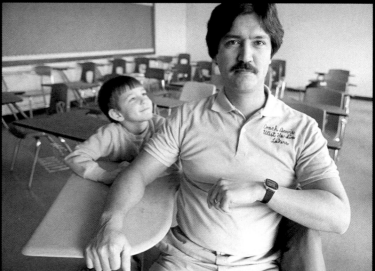

THE HABITS OF TODAY'S BUYERS

Finding the right vision for the right assignment is what buying is all about. In a single week, buyers at ad agencies will have many needs. The same buyer who on Monday has a need for a family lifestyle shooter, on Tuesday needs an illustrative product photographer. This is how it works everywhere, not just in advertising.

By demanding that you display a vision, clients are categorizing you not by *what* you shoot, but by *how* you photograph.

Are you capturing teen or family lifestyle? Are your portraits about what the person looks like or who they are inside? Do you use a specific visual technique that defines many different subjects? Do you photograph products literally, or as elements of design? The freedom offered by this new way of buying is visually liberating.

There is much more room for artistic expression in the world of commercial photography than ever before. With freedom comes responsibility, and yours is to work diligently to develop a vision that comes from within. Your talent and visual self-expression need to be clearly exhibited. This is a continual process, not just a portfolio exercise.

market a SINGLE VISION

Many photographers are afraid of marketing a single vision. They don't want it to appear as if they only do one type of photography, and thereby lose work. They try to be everything to everyone, which makes them nothing to everyone. They are missing the point. Marketing a single vision takes advantage of a photographer's strengths.

Ten years ago, it was common for photographers to have a portfolio that included different categories of photography, such as corporate location, food, still life, and portrait. That was when buyers were relationship-oriented. They worked with one photographer on everything. Now with an abundance of assignment photographers and stock photography, buyers are more sophisticated. They buy portfolios, not personalities.

Instead of shooting a lot of different categories, your portfolio should reflect a vision that can be applied to many categories. Different prospects will see your vision-based portfolio differently. They will decide what category your work fits into, so rather than being restrictive, this kind of approach leads to many opportunities.

The alternative is to present a portfolio with a variety of techniques, subjects, and styles, some that are strong and some that are weak. Unless you have been photographing for years, diligently developing your style in many different areas, and your talent is equally competitive in each, this is a big mistake.

Photographers feel that it limits creativity to show only one vision. They don't want to "do the same thing all the time." This is when I remind them that assignments should never be the only opportunity for creativity. You need to get into the habit of doing test shots, which push the envelope but don't always go into your portfolio. These tests might well reveal a new market for you to pursue.

"Consistency is key when creating a vision-based portfolio," says Kat Dalager, head of creative art buying for the Target Corporation. Kat, who buys photography globally, adds, "Resist the urge to chase the latest trend or throw in images that stray from your vision. Buyers don't want to try to hit a moving target, they want to know that they will hit the mark with *you*. An inconsistent vision will not prove to the buyer that you are 'well-rounded,' it will simply confuse them."

The reality of assignment photography is that clients buy *up*. In order to get good assignments you must show great work. The first step to great work is defining your vision.

BELOW Bill Smith is currently developing a new portfolio representing sports and travel. The images on this page and the next work very well together and contain Bill's signature tools which include a strong sense of graphic composition, intelligent use of color, and light as a directional and sculpting tool. The photo of the man kissing a fish is now being used for Mamiya cameras national print campaign. © *BILL SMITH*

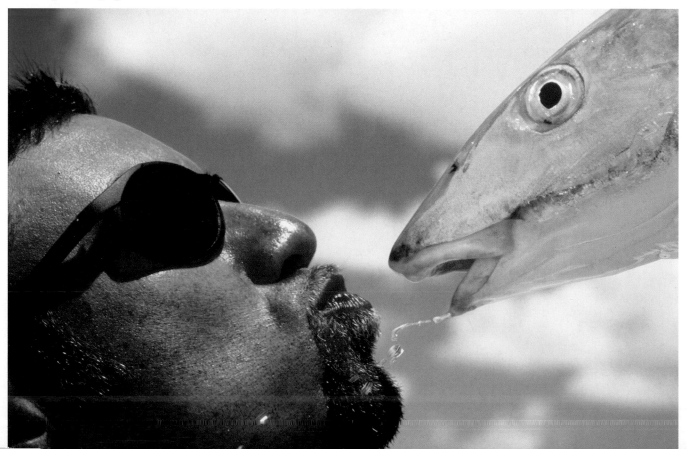

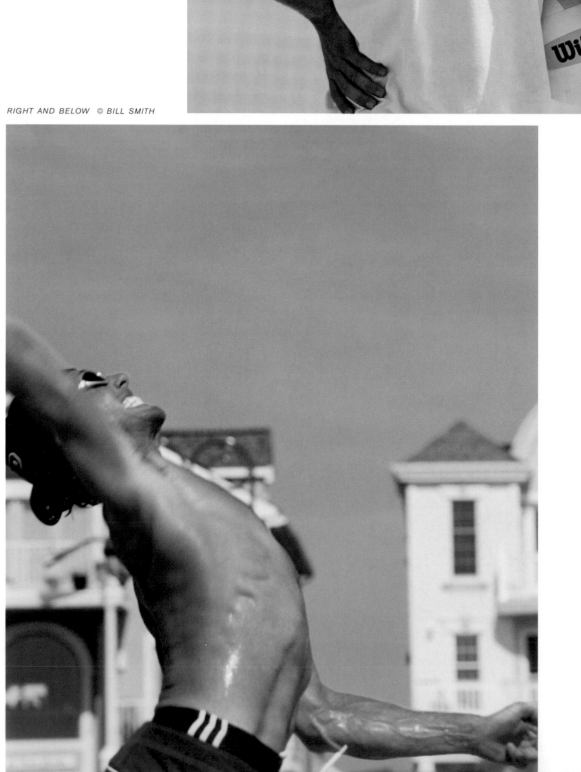

ABOVE AND LEFT Rick Souder's beverage shots are in-your-face, bold, colorful, graphic, and totally refreshing! Color, motion, and a tasteful sense of the abstract create highly illustrative images that are perfect for national beverage advertising campaigns. A buyer for a food and beverage campaign will look to Rick to create appetizing images, enticing viewers with big, bold photographs. © *RICK SOUDER*

portfolio exercise: LEARN BY SEEING

Each photographer has the ability to interpret the same scene differently. It is this difference in interpretation that speaks to the buyer.

To form your visual integrity you must begin by seeing. Pull tearsheets from magazines, sourcebooks, and award annuals. Focus on your area of interest, whether it be people, places, food, or corporate themes. As you explore, pull out the images that you wish you had produced—the ones that really knock you out. Gradually, you'll be able to isolate what your subject of interest is, as well as the way you shoot it.

Take about a dozen of these images and look at them more closely. Choose words that describe what you see.

Once you have images that represent your area of interest, begin to list on a piece of paper the elements that make up each image (composition, selective focus, color, texture, etc.).

Usually you will find a variety of elements, not just one, that keep popping up. Do you find elements that are consistently present? If the images you selected have nothing in common, start over. Often a second or third review is needed before you have truly gotten down to the images that resonate with you at the deepest level.

Now choose 5 to 7 all-time favorites from your work. Don't overlook your earlier work. The images you choose should resonate strongly with you. All should have true importance to you, and you have always loved them. Once you have made your selection, repeat the process described above, narrowing down the common elements of the pieces. Can you articulate what makes each image work?

When you are finished, compare the two lists. Note the tools you are attracted to, such as strong composition and different types of lighting. The elements you admire should be the ones you develop as you build your portfolio. You have begun to define your visual integrity! Retain this list and use it when developing concepts for new images and when you develop your positioning statement (see Chapter 2).

This is not an easy process. Photographers often find that the process of creation is one they take for granted, and therefore difficult to discuss and put into words. Try hard here; it is very important. What you are doing is tapping your unconscious mind, the place where creativity lies. You are waking it up and asking that it speak to you. In essence you are bringing to light what lies within, what is in your creative soul. You are beginning to define elements that will be included in your positioning statement.

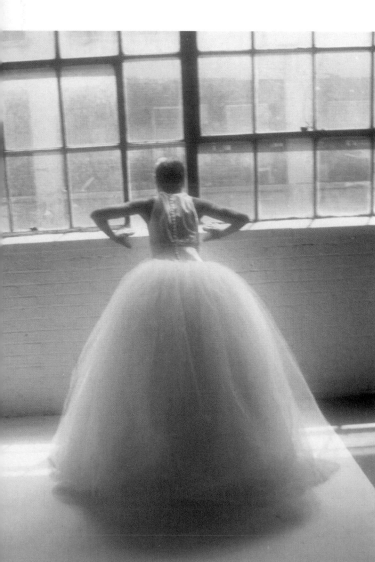

Joe Lee's bride is a contemporary look at an age-old family topic: marriage. © JOE LEE

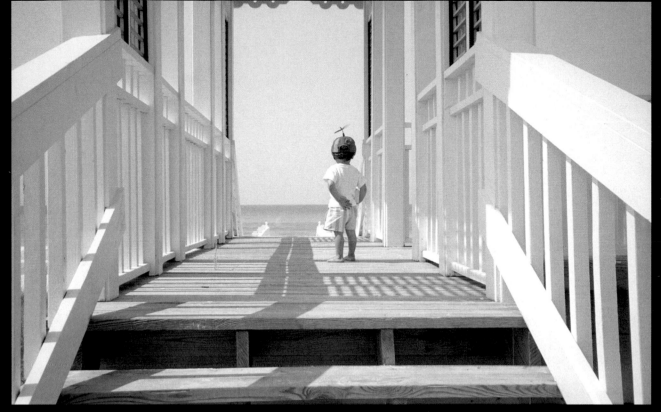

Carol Kaplan's photo of a boy on a beach house porch is evocative and reminds viewers of the feel of summer. Appropriate for a leisure or financial ad, it exclaims, "Put your money away today and have your vacation home for the grandkids!" © *CAROL KAPLAN*

ELAINE BROWN ON VISION

"It's hard to define what constitutes vision, as it comes in many forms. However, it's there or it's not, and it's obvious when a book contains little vision," says Elaine Brown, art buyer at Eisner Communications, who handles both national and regional accounts. "A book with vision contains a new way of seeing, work that goes beyond technique.

"Our process for buying photography is fairly consistent," she adds. "I go over the layout with the art directors and suggest photographers. These suggestions are made after I have gone through direct mail and promo cards, web sites, and source books. After the meeting, I call in the actual portfolios. Calling in 15 at a time is not unusual.

"A different kind of scrutiny happens when you call the books in. Once they are side by side, you can see how very different they really are. When you are doing a general search, you just respond to the work. But when you call in a book, you start applying the parameters of the assignment, and that's when you notice the difference between books. It's a different type of scrutiny."

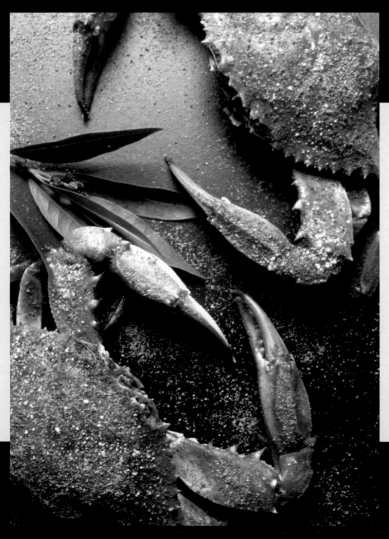

Food as art. Renee Comet is one of the best. This shot would make a perfect ad for a restaurant or for a leisure/tourism account. © *RENEE COMET*

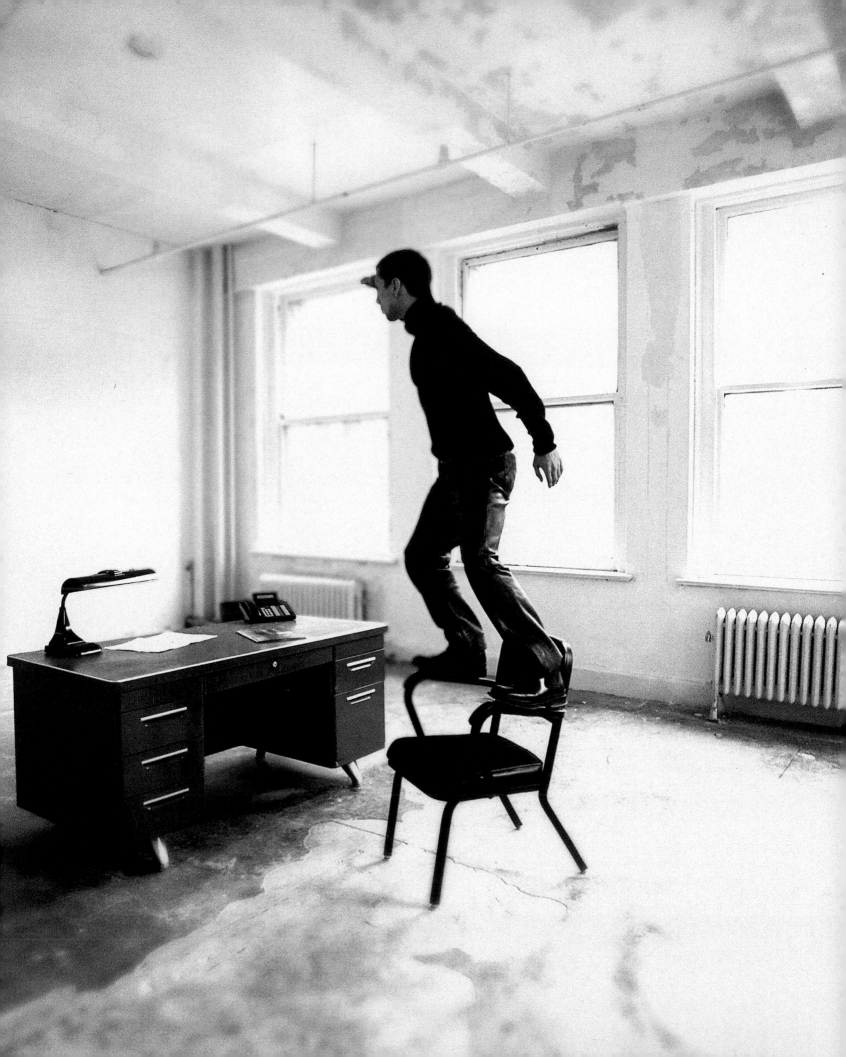

Creating a Positioning Statement

"IN THEORY, THERE IS NO DIFFERENCE BETWEEN THEORY AND PRACTICE. BUT, IN PRACTICE, THERE IS."

–JAN L.A. VAN DE SNEPSCHEUT, DUTCH-AMERICAN EDUCATOR (1953–1994)

All savvy advertisers know what the message of their product is before they create advertising materials. Only after they determine the product's market and the message to consumers do they develop a campaign. Similarly, you need to look at your photography as a product to sell.

The exercises in Chapter One helped you to determine your subject of interest and the way you shoot that subject. Now you need to articulate the message of your portfolio using your lists as tools. When clients review your portfolio, they need to get a strong sense of your style. To get your style across, you need to eliminate irrelevant shots from your portfolio and create new ones. How do you know which those are? By first establishing what I call a positioning statement.

LEFT Balancing fantasy and realism, this shot is bold, graphic, and contemporary. © *FRANCO VOGT*

BELOW Franco captures a humorous moment with careful consideration to composition. © *FRANCO VOGT*

ABOVE All of Franco's images feature people in an environment, with equal importance given to both. This shot is no exception. © *FRANCO VOGT*

RIGHT What is this man doing here in a suit? Franco's images are compelling, as they often ask more questions than they answer. © *FRANCO VOGT*

how to write a POSITIONING STATEMENT

A positioning statement is the verbal expression of your visual value. It is the message that you bring to each assignment, which you want viewers to get when they look at your work. It is the category that you are asking them to put you into. Who better to give them the idea of where to place you than you. As an internal tool, it helps you to edit old images and create new ones that adhere to your vision.

It is often difficult for photographers to write positioning statements because they are more comfortable expressing themselves with images than words. It is also hard for them to describe their own talent. But this statement encapsulates the message your portfolio is supposed to send to potential clients. If you can't figure it out what message that is, then buyers who view your book won't either.

YOUR POSITIONING STATEMENT MUST TAKE INTO ACCOUNT THE DEFINITIVE ASPECTS OF YOUR WORK, INCLUDING:

– Your area of specialty. (Are you a studio or location photographer? Are you a food, fashion, or lifestyle photographer?)

– The ways in which your work can be described. (Are your photos evocative and illustrative, or clean, bold, and graphic? Do your images look highly produced or are they more editorial?)

– The markets in which your type of photography is being used (advertising, graphic design firms, corporate editorial, architectural).

– The types of companies that need your type of photography (sports accessories, consumer fashion, food products, cars, and beauty).

– Your target geographic scope (local, regional, national).

What follows are two positioning statements: one for Franco Vogt and the other for O'Neil Arnold. As you look at their images, you can see how the words describe what these photographers shoot. Read each statement to see how it describes aspects or the feel of the imagery.

FRANCO VOGT'S POSITIONING STATEMENT

FRANCO VOGT CREATES BOLD, PASSIONATE IMAGES OF PEOPLE AND PLACES OUT OF THE FAMILIAR. HE APPROACHES SUBJECTS WITH VISUAL CLARITY, A CLASSIC SENSE OF COMPOSITION, AND FLUID COLOR. BALANCING FANTASY, EMOTION, AND DYNAMIC ENERGY WITH SHARP HUMOR, HE CREATES THE MOST MODERN RESULTS FOR THE ADVERTISING AND EDITORIAL MARKETS.

O'NEIL ARNOLD'S POSITIONING STATEMENT

O'NEIL ARNOLD CREATES PHOTOGRAPHS THAT CAPTURE THE ESSENCE OF HIS SUBJECTS AND MOMENTS IN TIME. HE DELIVERS BLACK-AND-WHITE AND COLOR IMAGES THAT ARE QUIET, YET DYNAMIC, THROUGH A PHOTOJOURNALISTIC EYE AND AN INSIDER'S VIEW OF THE CORPORATE WORLD.

WITH INTELLIGENT USE OF COLOR, THOUGHTFUL APPLICATION OF LIGHT, AND A STRONG CONNECTION TO HIS SUBJECTS, O'NEIL CREATES IMAGES THAT RESONATE WARMTH AND AUTHENTICITY. HE IS COMMITTED TO CREATING IMAGES THAT TELL STORIES—HIS CLIENTS' STORIES.

© O'NEIL ARNOLD

© O'NEIL ARNOLD

a portfolio exercise: CREATE TEST IMAGES

Testing is an ongoing process. One of the times to create test images is if you're having difficulty determining your positioning statement. Many photographers shoot only for assignments and not for themselves, so it's not surprising if their existing portfolios lack images that speak to their vision.

First, choose a commercial market that interests you. Create 3–5 images that you feel represent the current visual needs of that market. Then, ask a few friends whose opinions you value to help out. They don't need to be in the business. Simply ask them to view at least 5–7 of your new images and tell you what they see. Write it all down and then look for the consistencies in their observations.

There is no right or wrong way to do this. It is a living, breathing process that happens differently for everyone. In time, the definition and articulation will come.

I have often been asked if the positioning statement is static. Absolutely not. If you invest in your talent—shooting, experimenting, and developing your vision continually—your vision will change.

It should change. Shifts in vision happen frequently when a photographer invests a great deal of time and effort in the process.

Not every creative shift will require a new positioning statement. Some are very subtle. When you have five or more images that you feel represent a new direction, consider reviewing your efforts. If you determine that you will continue in the new vein, create a new statement.

If you still have difficulty with the idea of committing to a style of shooting, I must stress that I have never met a photographer who is beyond categorization, although I have worked with incredibly talented people. Everyone gets categorized simply because each photographer has strengths that viewers respond to.

The solution is to choose what to promote. Will you lose assignments? Absolutely, but you always lose assignments. You can never be up for all accounts. By failing to choose a direction for your portfolio you are losing accounts that you are most interested in visually, not just financially.

35

using your images AS A GUIDE

If you still can't put together a positioning statement, just start shooting. Let your images be your guide. Review them, using words to describe the feel of the images, the message, the tools. Sometimes, a photographer has to start building his new portfolio before writing his positioning statement. This is more common with new and emerging talent.

A case in point is Debbie Tam, who wanted to build a book geared to national advertising clients. Most of her work had been for modeling agencies. Specializing in children, Debbie wanted to showcase her ability to create a concept and cast and direct the shot appropriately. The images needed to be *evocative, moody, and create impact*. She tried to stick to these concepts when shooting new images for her portfolio. They became part of her positioning statement. The process of shooting and editing the images to fit her vision took six months. Her portfolio contains fifteen images. On the following page you can see examples of her edited images and her final choices.

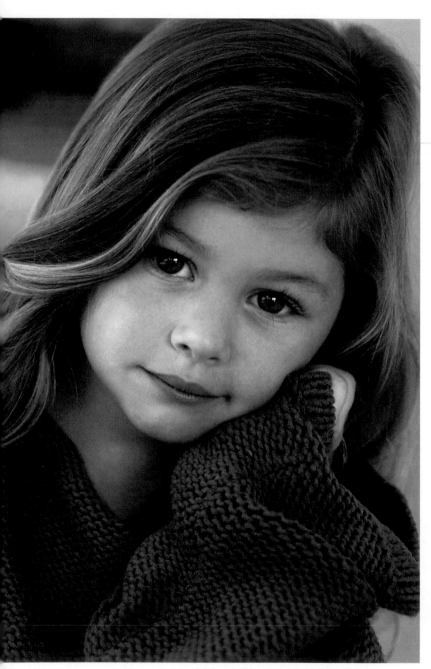

RIGHT AND OPPOSITE PAGE The following four shots are all an art director needs to grasp what Debbie does. All of the shots appear spontaneous, but they are highly produced. There is a minimal use of props, beautiful lighting and locations, and intuitive casting. These all help to make Debbie's vision come alive. These images are perfect for an editorial, advertising, or corporate client looking to sell children's fashion or products, as well as for the leisure industry. © DEBBIE TAM

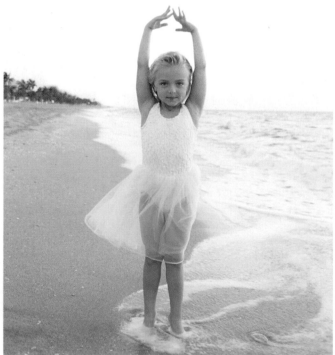

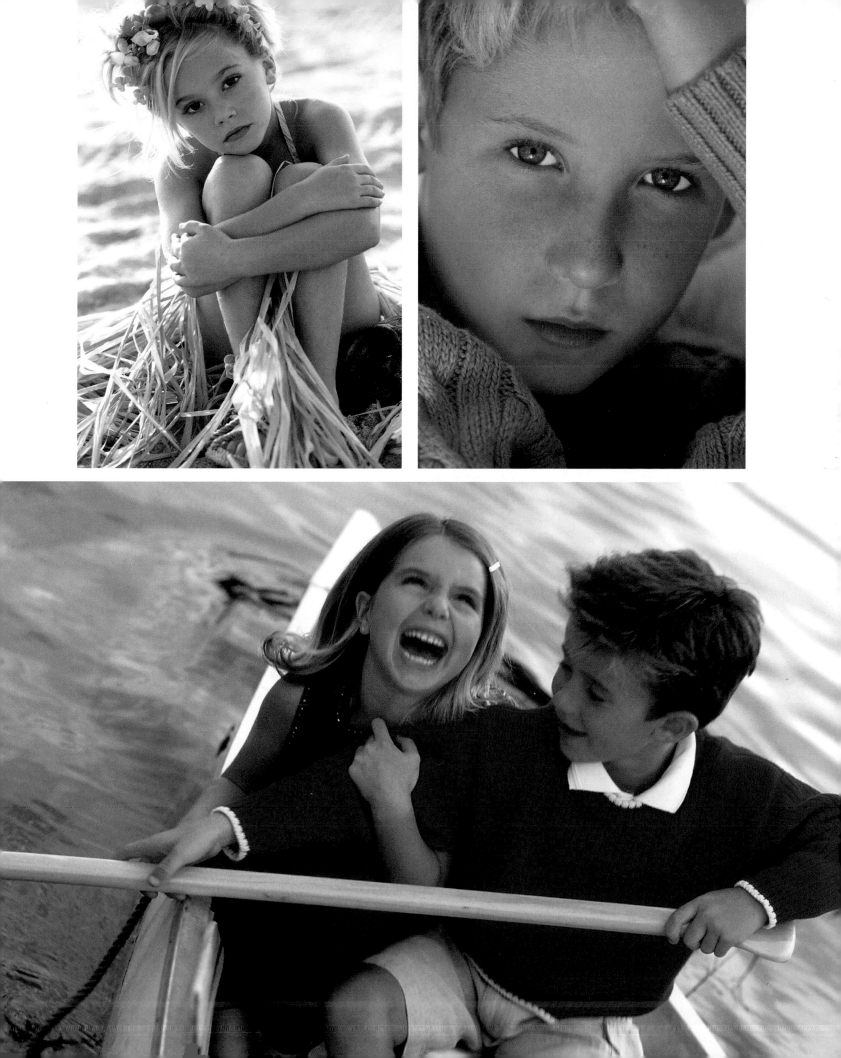

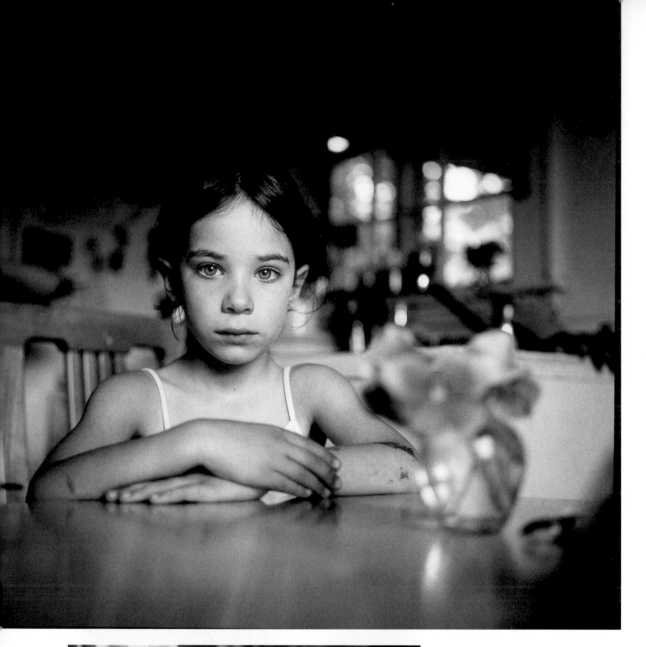

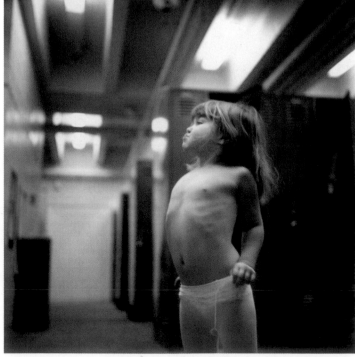

ABOVE, LEFT AND OPPOSITE PAGE Margaret Lampert has the ability to get across her subjects' personalities. All of her images attest to this. Working with black-and-white film, Margaret also uses light and composition as her main tools to create photographs that are real, warm, and subtly powerful. Perfect for financial, health care, and insurance ads, Margaret's images are consistent in vision and effect. © *MARGARET LAMPERT*

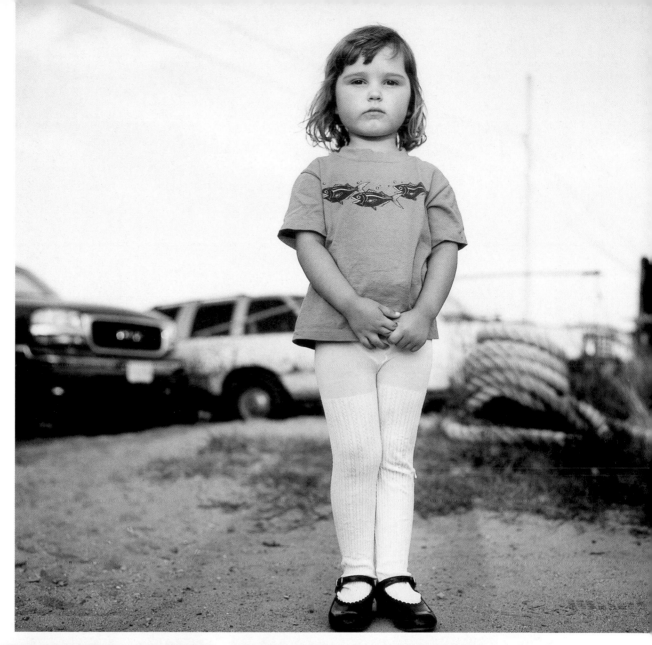

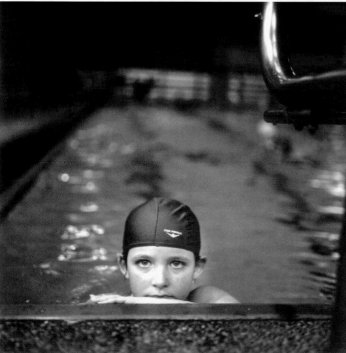

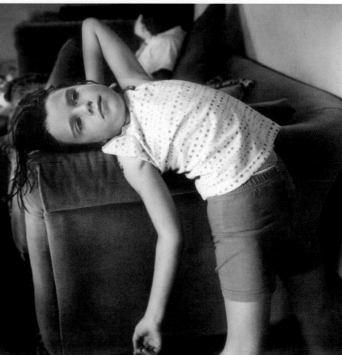

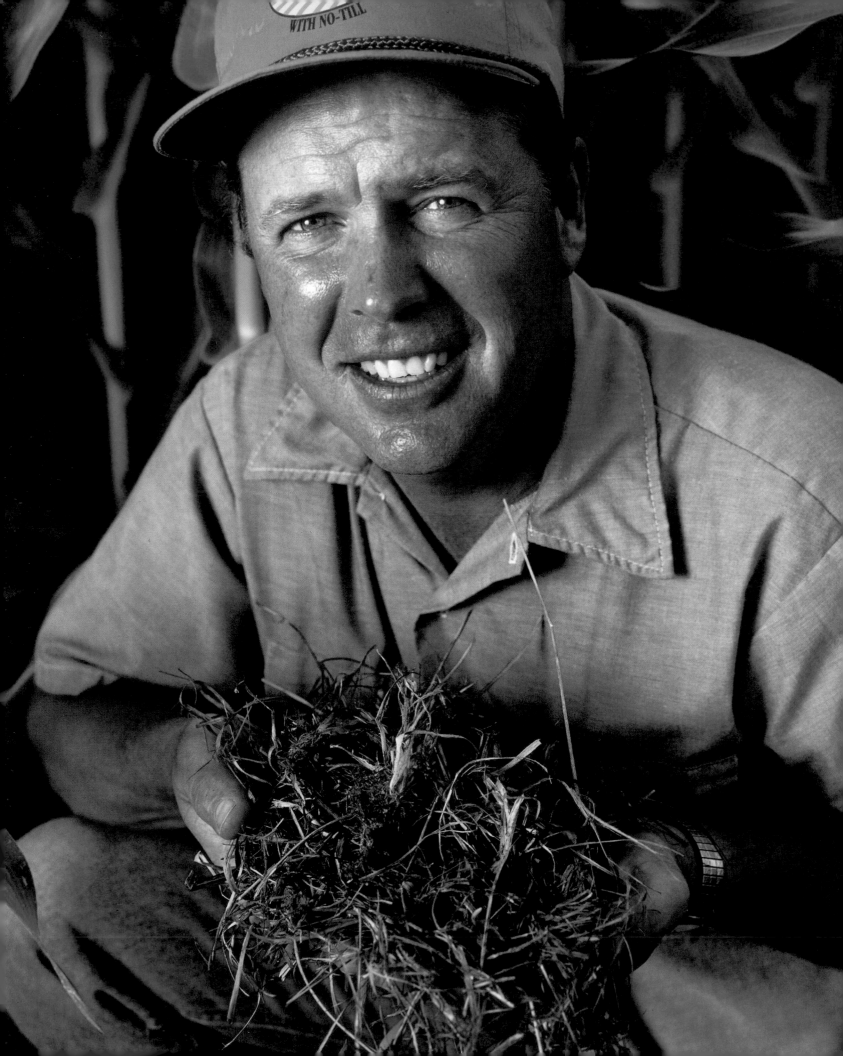

Market Application:
Know What The Market is Buying

**"USE WHAT TALENTS YOU POSSESS: THE WOODS WOULD BE VERY SILENT
IF NO BIRDS SANG THERE EXCEPT THOSE THAT SANG BEST."**

–HENRY VAN DYKE (1852–1933)

Before you build your book, you need to define your potential market. Familiarize yourself with your area of specialty. You need to become knowledgeable about buying trends and client needs. When looking at existing photography, you are not looking to replicate what already exists, but to simply become aware of what is being bought.

RIGHT Rich Pomerantz is an editorial photographer. His imagery revolves around people in outdoor spaces, often gardens. The people that inhabit Rich's photographs become props in his photographs. Whimsical, quiet and visually graphic, Rich's images have been published in national magazines.
© *RICH POMERANTZ*

OPPOSITE PAGE In this shot, Dave established a direct connection between himself and the farmer. This connection together with a strong sense of graphics, it is a perfect shot for editorial, design, or corporate use. © *DAVE ULMER*

EDITORIAL

Years ago, fewer publications existed. Although each magazine had its own perspective, it addressed a wide audience with varied interests. The visuals used ran the gamut from food to still life to people. The style of the images was less important than the subject of the shot. Often, the copy was more important than the visual.

Today, each magazine on the shelf has a very specific point of view, a targeted message for its readers, and a very defined look. Publications now look to reach readers who have certain hobbies, ways of life, or outlooks. Each magazine is looking to distinguish itself from the crowd. As important as the content of each story is, the images are what immediately get the viewer's attention and give the publication a visual edge.

Just look at a single category, such as business publications. You will see that each magazine covers stories with a different editorial slant and a different visual style. *Fast Company* is a popular business publication that features articles on attitudes, environments, and unusual occupations in the world of business. The photographs used in *Fast Company* are colorful, hip, dynamic, and highly illustrative. *Fortune* magazine, the granddaddy of business journals, covers the news and trends that affect the nation's economy. Thus, it uses images that are less illustrative and often involve more literal photography and, often, environmental portraits.

LEFT Rich Pomerantz gave this editorial photo, shot for *Garden Design* magazine, an eyecatching focus in Julie Kent, the principal dancer for the American Ballet Theatre. © *RICH POMERANTZ*

OPPOSITE PAGE In this image, shot for *Horticulture* magazine, Rich Pomerantz uses color to define composition. © *RICH POMERANTZ*

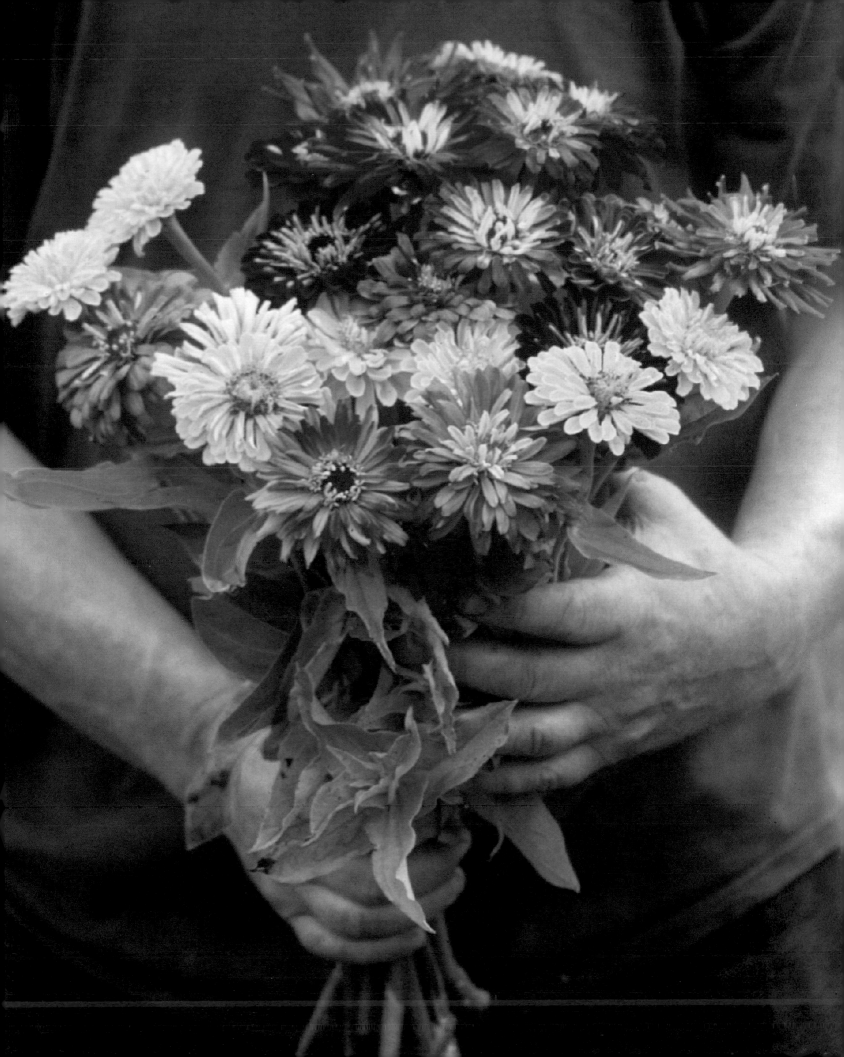

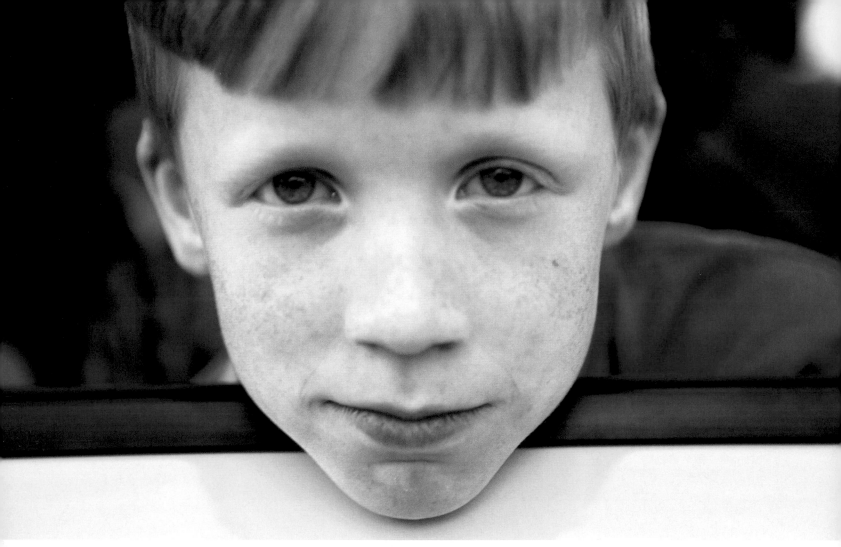

Brian Warling's image was shot for his new portfolio, which features children. It includes wonderful portraits shot in the studio and on location. The photo reproduced here would be perfect for many national advertising campaigns that sell children's clothing or products. © *BRIAN WARLING*

ADVERTISING

Look at the images used by today's advertisers to sell their products or services and you will see one very important trend. The visuals used to sell are rarely product shots. Rather, advertisers today use illustrative photography that evokes emotions and desires. It is designed to show consumers how the product or service will affect their lives. Advertisers want to tell consumers what their lifestyles could and should be. Through photography, they want to show how their service can improve quality of life, save time, or provide more security or excitement. They appeal not to the mind, but rather to the emotions.

The change in the kind of message advertisers are sending—from what the product looks like to how it will affect your life—ushered in a need for a new type of visual. The look is often big and bold, with lots of selective focus and minimal propping. Color palettes vary from bright neon colors to subtle, more sophisticated tones. Photographs that look more artistic than literal are being requested. Black-and-white photography, once not accepted for advertisements, is now hugely popular.

Another change is in how people are used in images. The subjects no longer take static poses, smiling into the camera. Propped-up models showing little depth or emotion are out. People are captured in a moment. Contemplation, happiness, joy, and connection are major themes. National campaigns featuring people photographed in an editorial or portrait style are often used to sell products (Milk Council, Timex, Ebel, Gap) or services.

Lifestyle photography, or the creation of images that represent a way of living, is extremely popular. These are looser images that speak to pivotal moments in a person's life, feelings, and the way we live. Even if they are highly produced and styled, they look as if the photographer just happened upon the scene and snapped the photo. Lifestyle photography has many sub-categories. Photographers can specialize in family, teen, senior, or business lifestyle.

CORPORATE PHOTOGRAPHY

Corporations buy photography for annual reports, capability brochures, web sites, and other external and internal publications. Assignments may come directly from the corporate buyer, such as a director of corporate communications or marketing director, or through a graphic design firm. It is their job to deliver the corporate message. Today, the corporate message can be about the company's mission, as much as the product, although both are vastly different.

As in advertising, visuals used in the corporate world have also undergone a great change. Corporate buyers are more visually savvy. They often buy stock photography, but look to assignment photographers to provide unique visuals. Black-and-white photography is often used, as are editorial or documentary styles of shooting.

To get a feel of what this segment of the market is buying, look at corporate or design studio web sites, design annuals published by *Communication Arts, Print,* and *Graphis* magazines, and annual reports.

You can view the web sites of architectural firms, design firms, corporations, and ad agencies. Look at the images displayed. Are they using photography creatively, or are they exhibiting a need for new creative visuals? What message is each firm striving to communicate to its audience? Can your photography help a company to communicate its message?

O'Neil Arnold shot this portrait of a corporate executive and his dog in very warm light. It is representative of the best of today's corporate environmental portraiture, showing more about the person than his position. © *O'NEIL ARNOLD*

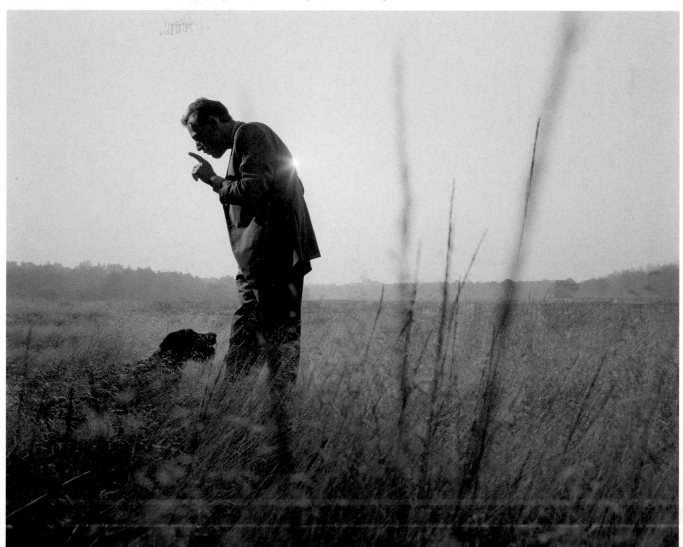

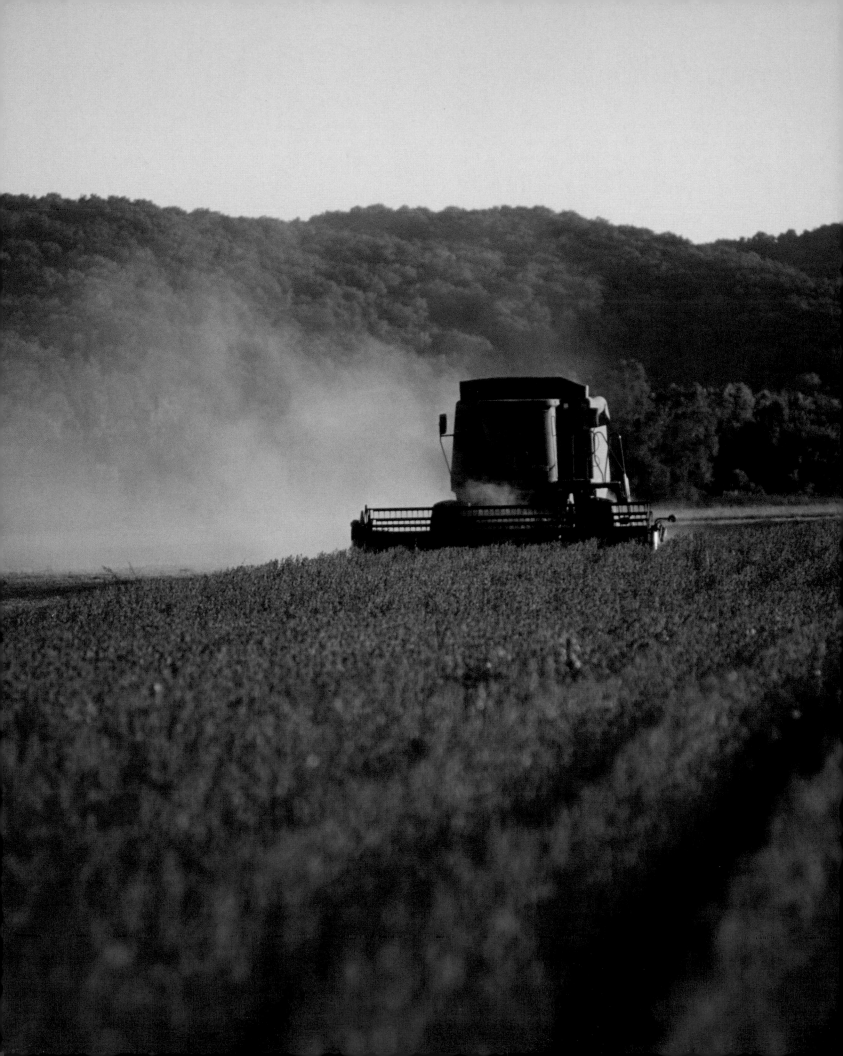

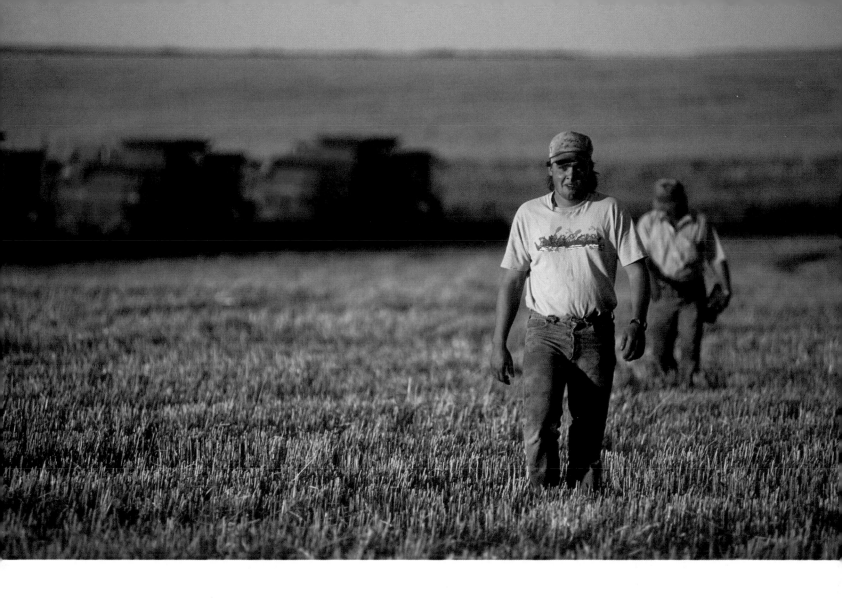

Dave Ulmer uses an editorial vision when shooting for corporate clients. Specifically, he photographs people and places related to the agricultural and water industries. The following photos could be cross-marketed to graphic designers, corporations, and editorial photo buyers.

ABOVE This visual is a strong editorial image that gives us a palpable feeling for the land. Dave's use of light creates a magical moment in time. © DAVE ULMER

OPPOSITE PAGE In this image Dave shows farm equipment at work, using his visual style to create a dynamic photo. © DAVE ULMER

SECONDARY MARKETS

After reviewing the work now being used in your area of the market, begin to list the markets for which your work is appropriate. Remember to consider cross-markets.

For instance, if you shoot architecture your key market would be architectural firms but secondary markets might be interior designers, corporations (annual reports use architectural images), builder/developers, and building product supply companies.

As a corporate location shooter you might target the graphic design community primarily, and different corporate contacts would make up your secondary targets. Corporate communication directors, mar-com professionals (marketing/communications), and web design contacts all might be possible leads.

As an editorial photographer you might aim for consumer magazines, but do not overlook corporate in-house publications, and industry and organizational trade publications.

As an advertising photographer your talent and area of concentration will help you to determine your various cross-markets. A photographer focusing on family lifestyle might consider the ad market first, approaching art buyers in agencies. However, corporate communication directors at companies that sell family oriented products or services (such as health care, insurance and consumer products) would be an appropriate second hit. Family editorial publications would work as well.

There are many options for most photographers, however, the vast majority of talent narrow their potential market from the get-go. This is a huge mistake that impacts the business before the portfolio has even been created.

a portfolio exercise: INVESTIGATE YOUR MARKET

Look at the area of specialty that interests you. Use the same tearsheets you used in the exercise in Chapter One, but this time, look at them differently, as if you are the buyer. Your job is to determine what type of images your chosen market is buying.

If you're interested in the advertising market, you'll be looking at ads. What do the images look like? What are the color palettes being used? Can you identify specific photographic techniques? It helps to look at the actual product as well as the piece that advertises it.

If you want to focus on food, look at the editorial and advertising markets. What is the difference when food is shot with these different purposes in mind? Is there a difference at all? What are the visual trends at work? The editorial market is huge, with many new publications popping up all of the time. Look at them to

see how the photography changes depending on the audience. A tea box photographed in an illustrative style, where the box is shot as a graphic element, can be attractive to an editorial as well as advertising client.

For corporate work, look at annual reports and collateral material, such as identity brochures and web pages. What messages are corporations communicating to consumers?

The idea is to become knowledgeable about buying trends and client needs. You are not looking to replicate what already exists.

And as always, keep up to date with industry periodicals, such as *Adweek, Graphic Design USA, Step-by-Step Graphics, PDN, How, Communication Arts, Print,* and *Graphis*.

OPPOSITE PAGE Bill Smith incorporates strong composition and lighting in his architectural photography. For example, he will choose to focus on part of a room rather than its entirety, thus creating an image with a sense of intimacy and immediacy. Viewers are drawn in. Illustrative, rather than documentary in style, Bill's images are appropriate for editorial work, as well as for advertising and architectural clients. © *BILL SMITH*

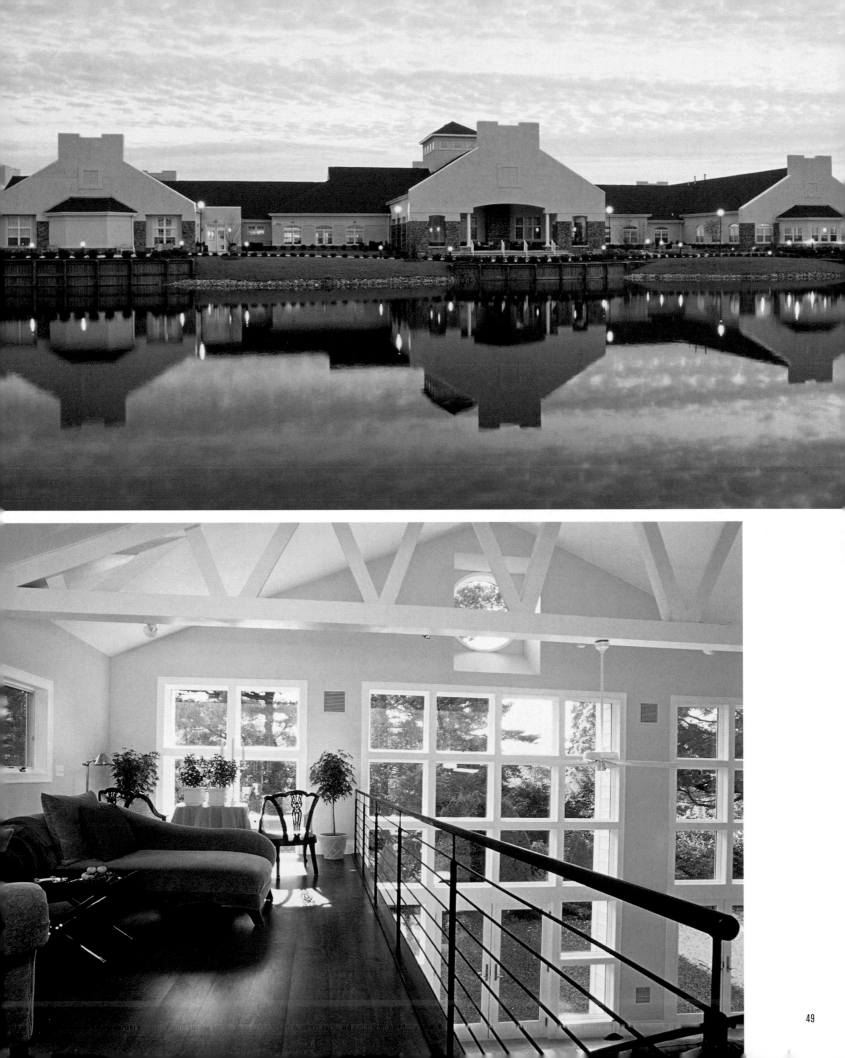

Editing Existing Images

"I HAVE LIVED IN THIS WORLD JUST LONG ENOUGH TO LOOK CAREFULLY THE SECOND TIME INTO THINGS THAT I AM MOST CERTAIN OF THE FIRST TIME."

—JOSH BILLINGS, AMERICAN HUMORIST (1818–1885)

A portfolio that sells has two sections: a gallery section and a tearsheet section, in which you show published examples of your work (see Chapter 11). The gallery section is what we've been discussing. It's where you show viewers what you do and how you do it. As you build your gallery section, pay close attention to market application and your positioning statement. They are key to creating a book that sells.

It is hard to specify how many pages to include in the gallery section of your book, but plan on keeping it to around 15–20 images. Viewers shouldn't need to see more than that to get your defined and redefined vision. It is the strength of your vision, the content of the images and how they apply to the buyer's current needs and tastes that matter.

LEFT John Soares photographed Ken Jewell for *Fast Company* magazine. Jewell, a designer at Design Continuum, Inc., sees himself as an "observer of life," a visionary, and that is what John sought to capture. © JOHN SOARES

OPPOSITE PAGE Again for *Fast Company*, John Soares photographed Matthew Grant of MacTemp, a company that advances the cause of the independent, project-oriented professional. © JOHN SOARES

apply your POSITIONING STATEMENT

Now that you've familiarized yourself with current styles and the markets you want to target, it is time to use the positioning statement that you have created. Your statement is not just verbiage. It is what you will use to edit the existing images in your portfolio. This is the first step when building the gallery section of your new portfolio.

AS I WORK WITH PHOTOGRAPHERS ON EDITING THEIR PORTFOLIOS, I OFTEN HEAR THE SAME COMMENTS:

– "I am tired of this photograph but everybody loves it, so it's got to go in."

When editing existing work, look at the shots that generated good responses, or those which you love. If they communicate a part of your current positioning statement they stay in your portfolio. If not, they go. You can save the ones you reject as an alternate, when a client requests a specific subject for a pending assignment.

– "I know it's not the strongest shot I have, but it is a computer shot and this market is all about computers."

If you need a specific type of shot, make sure the example you include in your book represents your visual integrity. The subject of the shot is not the message. How you represent the subject is.

– "The color might be off, but this shot is an example of a new technique that I am nuts about."

You must resist including an image that represents a new technology until you have mastered the process. Many photographers can't resist including images that were shot recently or created for new clients. They feel that their latest work is their best. They get tired of seeing the same images over and over. However, your clients are not you. They need to see your book, and any other materials, over and over in order to remember you. Consider adding any new, appropriate images to a web site, or for your next portfolio (see Chapter 12).

OPPOSITE PAGE, TOP These two photographs shot for an annual report represent a new visual direction for one of the nation's top corporate photographers, Ted Horowitz. When editing existing imagery, he realized that he needed new photographs, as his existing work did not speak to his positioning statement. He shifted his visual style by using a different color palette and an emphasis on composition and people. These biotech workers shot in contemporary lighting made for a very graphic image. © *TED HOROWITZ*

OPPOSITE PAGE, BOTTOM A scientist in a pharmaceutical research lab. Ted chose a color palette that was more modern and cropped the shot closely in order to create a dramatic image. Ted was going after corporations and graphic design firms that hire location photographers. © *TED HOROWITZ*

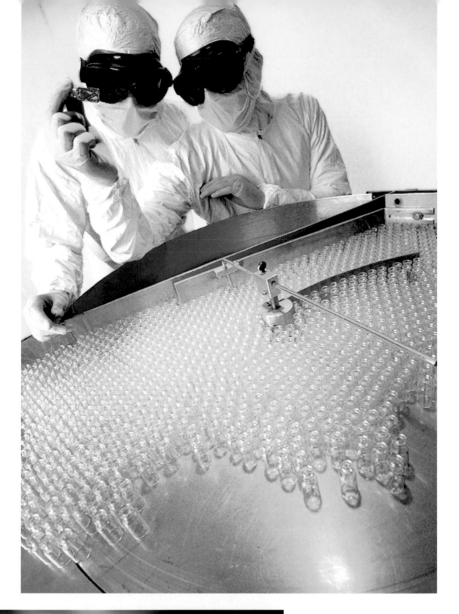

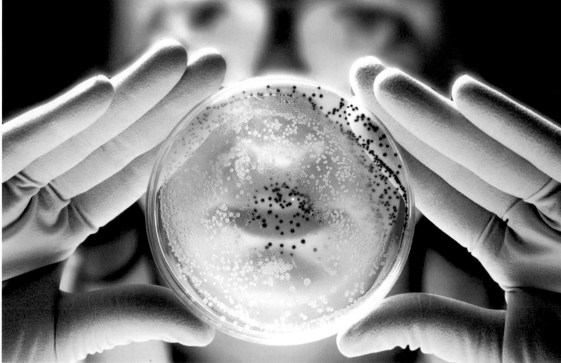

a portfolio exercise: ASSESS EXISTING IMAGES

When choosing images to keep, don't fall into the trap of retaining a core group of photos that have repeatedly gotten a strong response, unless they apply to your positioning statement. If an image doesn't communicate your visual integrity, it goes. Lose your emotional connection to your images when editing. Remember, your portfolio should reflect the direction you are going in, not where you have been.

REVIEW EACH OF YOUR EXISTING IMAGES WITH A MIND TO CHOOSING THOSE THAT ANSWER THE FOLLOWING IN THE AFFIRMATIVE:

- Does it communicate what is in your positioning statement?

- Does it represent the type of image currently used by your target clientele?

- Does it represent something new and different to the market, and yet commercially viable?

Examine the specifics of each photograph that you have chosen. First, look for signs of age. Hair, makeup, and clothing can quickly date your work. Color trends also change quickly. Photographs of the 80s were characterized by heavy, saturated spots of color, and in the 90s by cross-processing. This has been followed by softer pastel shades or their complete opposite, vivid bright colors.

Check for any dated technical style, including the use of light. Lightpainting was a popular style in stil-life photography that was popular in the late 80s to early 90s. Shooting still-life images close up, with lots of selective focus, is a current trend.

In order for your portfolio to be relevant, your images have to look contemporary, not dated. Your job is to know what styles are selling and then to choose existing images that represent your new direction.

determine how many IMAGES TO ADD

At this stage, when you have edited your existing images, it's a good time to approximate how many new images you will need to complete your gallery section. This is not the final edit, which you will do at a later stage, when you have chosen the format for your portfolio presentation (see Chapter 10).

Earlier, we established that the gallery section of a portfolio need only be 15-20 images, since your vision should be strong enough to get across with no more. In my experience, after making their selection from among existing images, photographers have about one third of their book. The remaining nine or so images have to be created from scratch.

If it turns out that you only have two or three images that work, and you have another 12 to shoot, don't panic. Rejoice! This may be the first time in your career that you have an opportunity to develop your vision, instead of letting it shift assignment after assignment.

RIGHT AND BELOW As strong as these two images are, John edited them out of his portfolio because they did not fit in with his positioning statement at the time. The steel guitar, shot for a sign in the HEAR Music stores, is more gritty and has less of a narrative than his final portfolio shots. The "scooter chase," shot for a CD insert, was a little too light-hearted and not in keeping with the style of his portraits. © JOHN SOARES

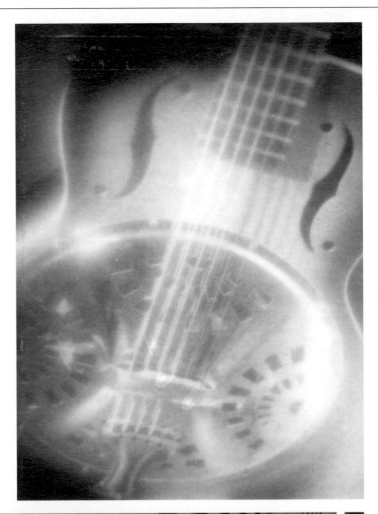

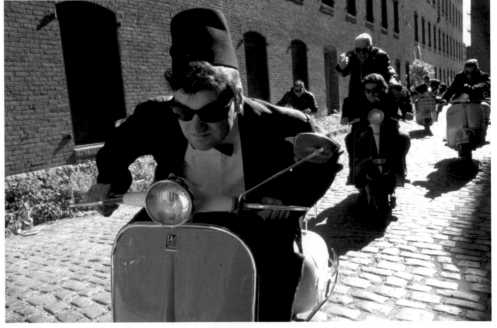

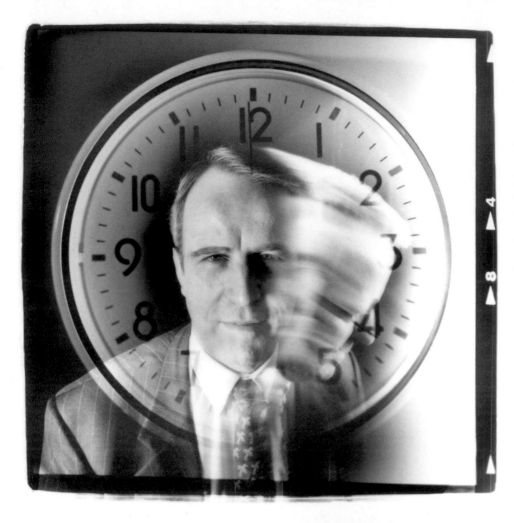

John Soares is an editorial photographer who shoots for many national publications. Shown here (and at the beginning of this chapter) are assignments that John has photographed for *Fast Company*. An award-winning magazine, *Fast Company* is known for writing about off-beat business topics. John's visuals are a wonderful fit for the magazine, considering his use of light, camera angles, and humor. His photos of entrepreneurs featured in *Fast Company* capture each individual's idiosyncratic style.

LEFT Dr. Martin Moore, president and CEO of Circadian Technologies, Inc., and an expert on biological clocks, as seen through John's lens. © *JOHN SOARES*

RIGHT A pioneer in systems thinking, Barry Oshry has written extensively on organizational power and powerlessness. Here, he literally vibrates
energy and power. © *JOHN SOARES*

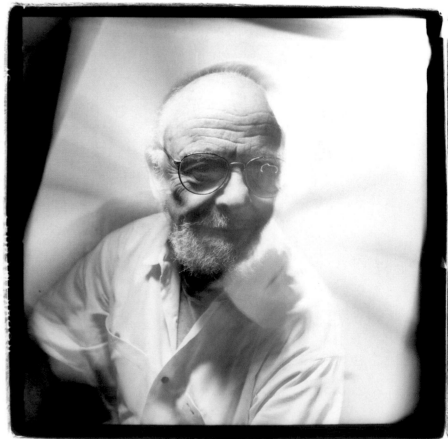

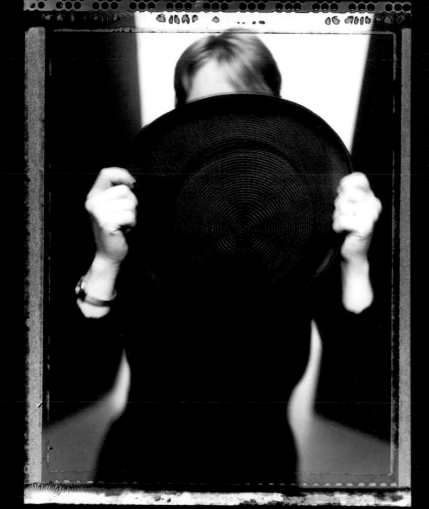

TWO INDUSTRY VOICES

Karen Frank, the director of photography for O, Oprah Winfrey's magazine, says that "vision needs to be present" in a portfolio. "Photographers must show consistency of vision throughout the book. We take chances when we hire a new photographer. Seeing a few great shots doesn't convince me. I need to see the photographer's complete portfolio in order to believe that I can trust him."

Alicia Jylkka, photo editor at Fast Company magazine, says, "Vision is hard to define. It's either there or it's not. Sometimes I'll go through a book and like a few images, but find that the overall book does not impress. Then, I pick up a book and every image shouts, Wow. That's a book that has consistent vision. Maybe 30 percent of all unsolicited books have the power to make me want to see more."

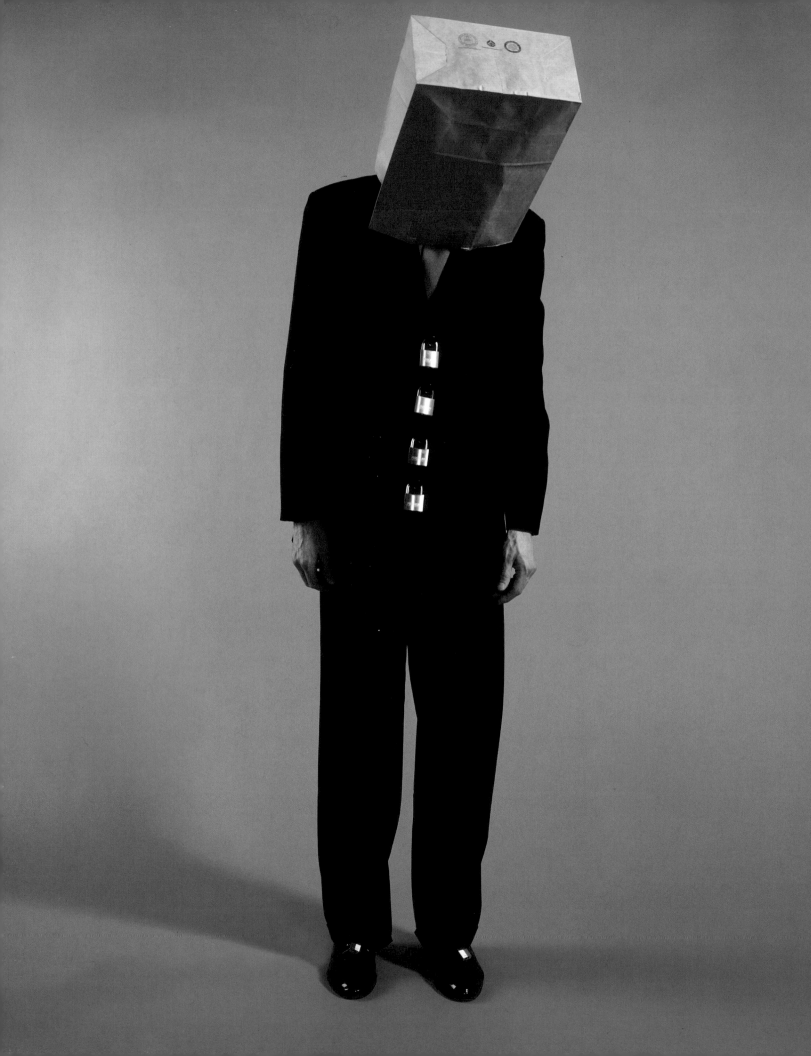

Creating New Images

**"GREAT RESULTS CANNOT BE ACHIEVED AT ONCE, AND WE MUST BE SATISFIED
TO ADVANCE IN LIFE AS WE WALK—STEP BY STEP."**

–SAMUEL SMILES, SCOTTISH WRITER (1812–1904)

Having chosen the photos that you want to retain in your portfolio, you need to figure out what is missing. What part of your positioning statement still needs to be communicated? Remember, your goal is to create a portfolio that delivers your message while showing various applications of your talent.

BELOW AND OPPOSITE PAGE Patrick Prothe wanted to add people into his portfolio, while retaining his trademark look—bold, dynamic shots reflecting his unusual sense of humor. Among the images are a headless man and a suitless tie. Irreverent and quirky, they seemed to be a good match. © *PATRICK PROTHE*

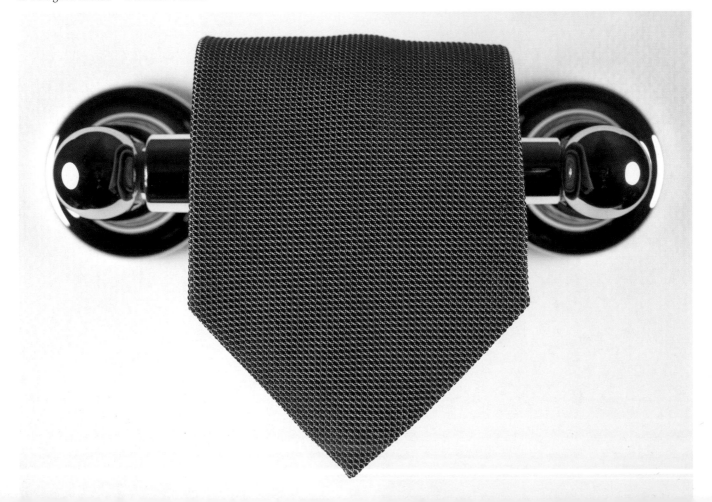

rounding out YOUR MESSAGE

Give yourself plenty of time. You may need to reshoot a few times before an image is nailed down. Don't become discouraged if you have many images to create. When building a book, most photographers have at least 60-70 percent of the book to shoot.

Look at the images you have edited in and begin to decide what type of images you will need to add, in order for your new portfolio to fully communicate your message. As you begin to list the types of images needed, let the exisiting shots be your guide. As an example of how this works, let's look at Patrick Prothe's portfolio challenge.

Patrick was a graphic designer who repositioned himself as a photographer. His portfolio of still life images received a positive response from ad agencies, design firms, and retail corporations. The images were bold and dynamic, featuring lots of color and strong composition, and they reflected Patrick's unusual sense of humor. Yet they were simple and elegant.

However, Patrick felt that he needed to add images with people in order to attract new advertising and graphic design clients. These new images would have to match the feel and vision of the still life photos that were already part of his portfolio. To achieve this, the new images were kept simple, with few props, other than the models themselves. Patrick's humor and strong sense of composition continued to be present.

BELOW AND OPPOSITE PAGE, BOTTOM These two photos, positioned opposite each other in Patrick's portfolio, are unified by color, while the ideas they convey-one of stress and the other of quiet and comfort-contrast. © *PATRICK PROTHE*

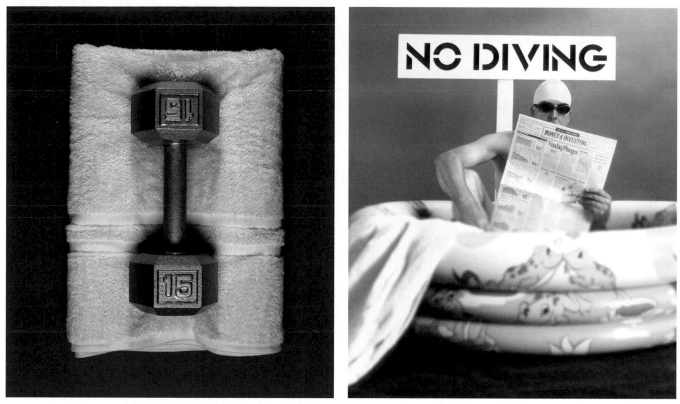

ABOVE, LEFT AND RIGHT Subject matter and color work to unify these two images. The purple background and the terry-cloth towel are common elements in each photo. © PATRICK PROTHE

steps to a SUCCESSFUL SHOOT

AS YOU START, KEEP IN MIND THAT ALTHOUGH PHOTOGRAPHERS HAVE DIFFERENT TIMELINES AND WAYS OF WORKING, THERE ARE SOME STEPS THAT EVERYONE TAKES. THE STEPS ARE:

– Developing Your Support Team

– Conceptualizing

– Organizing the Shoot

– Shooting

– Editing

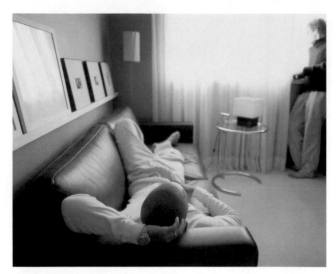

© ROBERT KENT MELNYCHUK

1. DEVELOPING YOUR SUPPORT TEAM

Creating a new vision-based portfolio can be a team effort, comprising consultants, assistants, designers, digital artists, and art directors. You have to analyze your own limitations and needs. If you need help with hair, makeup, and props, then go to a stylist. Often new and even experienced stylists will work for free in exchange for an opportunity to update their work. If you need help with conceptualizing, contact a friend who is an art director or graphic designer, or work with a creative consultant. My job as a consultant is to work with photographers on conceptualizing, critiquing new imagery, staying on track, and editing. My clients count on me to be a team member who keeps them accountable.

You may feel that you can't afford support, but you can't afford not to have it. You need to invest time, energy, and money in your portfolio. If you don't, why should the client?

Well known in the worlds of stock and architectural photography, Robert Kent Melnychuk was ready to make an impact in the American advertising industry. Rob believed strongly in working with a production team as he created new images. We can learn a lot from Rob about teamwork and the art of creating images in a highly inclusive atmosphere. "The best idea wins! Not just mine," says Rob. "We start with a brainstorm meeting and conceptualize as a team. We always have a post-production meeting, where we ask ourselves what worked and what didn't, and what we could have done better."

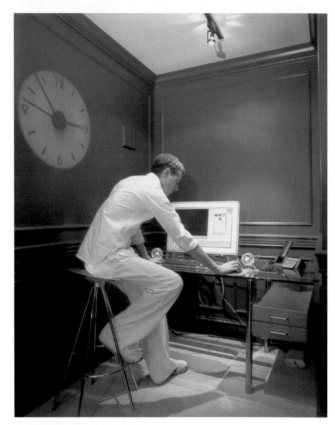

© ROBERT KENT MELNYCHUK

The concept behind one section of Rob's new portfolio is the "Digital Home." The portfolio was created by Rob's entire team. The photographs represent his ability to conceive and execute images that represent a very hip lifestyle that embraces technology. His background as an architectural photographer comes through, as locations are clearly as important to the photo as the people are. Rob has a unique way of shooting. Using motion, body parts, and selected portions of a location, Rob's visual style allows us to feel as if we are voyeurs, peeking into a world that others occupy.

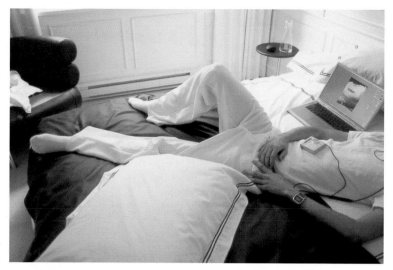

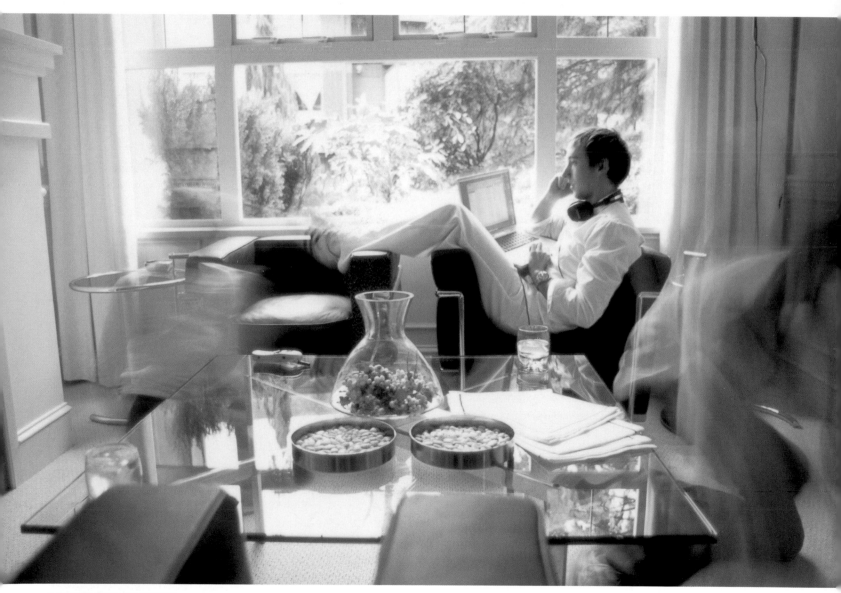

2. CONCEPTUALIZING

Devising the concept for an image can be difficult in the absence of the clearly defined parameters of a paying assignment. Refer to your list of images to create. Brainstorm by yourself or with a team member and expand on your ideas. You need to consider not only what a shot will look like, but how it will fit into your positioning statement. At this stage, it is often tempting to try a new technique or simply create something completely different. While the idea of expanding your visual horizon is a good one, make sure that your concept contributes to the visual integrity of your portfolio. Furthermore, you don't want to repeat ideas that are already conveyed in the existing images in your portfolio. Remember to think as the client. Your portfolio is the product you are selling. Create photographs that will sell your product.

John Mowers wanted to reposition his studio. FORTÉ Studio now offers clients the opportunity to buy photography and post-production services. Therefore, the studio's portfolio had to showcase a combination of John's vision and the work of Russell Kerr, the studio's digital artist. John conceptualized and shot the photos, then consulted with Russell on post-production. The final result reflects their teamwork and illustrates the value that the FORTÉ Studio brings to each assignment. They successfully cross-market to the editorial, corporate, and advertising markets.

The concept behind John's new people portfolio was "lifestyles." In it, two completely different lifestyles are represented. In the images shown, John was interested in capturing the distinct personalities of a group of young adults living together. Russell digitally enhanced and created a new color palette for the images to attain the feel that John was looking for. The copy serves to add color to each subject, and gives the viewer a glimpse into John's sense of play.

3. ORGANIZING THE SHOOT

Although this seems to be the most time-consuming part of the process, doing it right can save you time in the long run. Spend time gathering props and working with a stylist, if needed.

4. SHOOTING

As with the rest of the process, it's important to schedule time to do your shoot. Block out times to scout locations, cast, gather props, and shoot. Make sure to put the times on your assignment calendar, as you would with a paying assignment. Now get to work and create. Be prepared to shoot a few variations of the shot, with changes of wardrobe, locations, people, and angles. When working with groups go for opportunities to shoot moments of interaction and portraits.

BELOW AND OPPOSITE PAGE The following images are from one section of Forté Studio's new lifestyles portfolio. The book has two sections, one on hip-hop lifestyle and one on outdoor lifestyle. The goal was to communicate that one consistent vision can interpret two vastly different ways to live. The portfolio was a true collaboration between John and Russell Kerr. At one point, John played with the idea of putting titles under each photograph. He wanted the viewer to have more information. He later decided that the images spoke well enough on their own. While I agree with John's decision, I have chosen to include John's titles in order for you to see how copy used in a portfolio can indeed work.

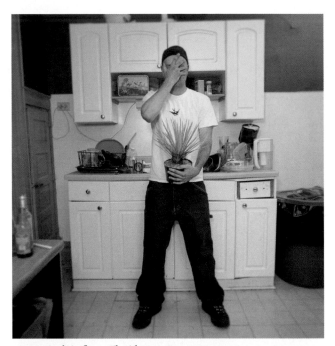

ABOVE Jack is from Florida. © *JOHN MOWERS*

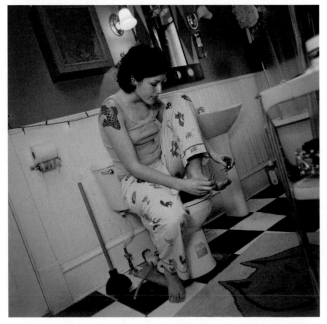

ABOVE Megan has excellent personal hygiene. © *JOHN MOWERS*

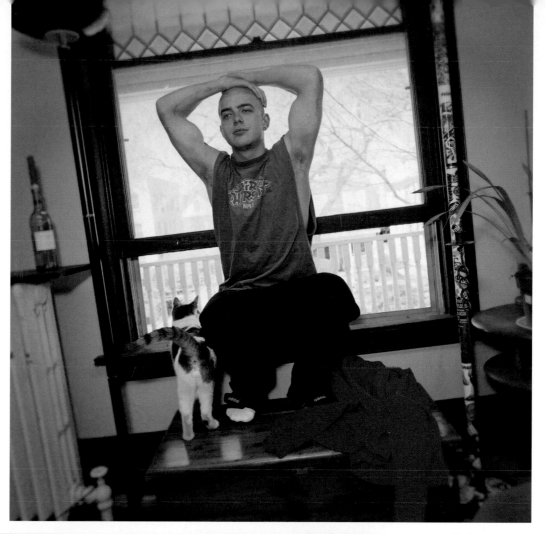

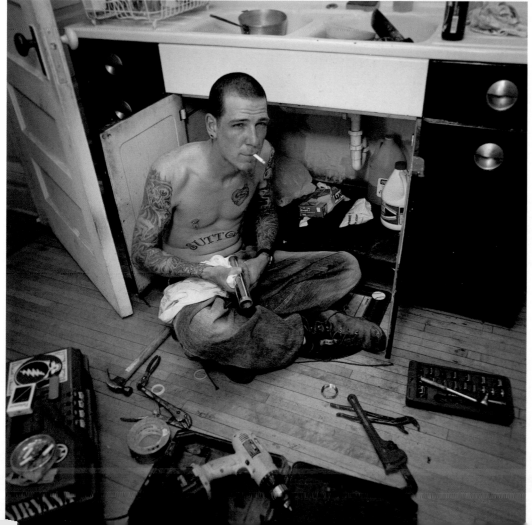

ABOVE Dan died twice.

© JOHN MOWERS

LEFT Jack is a plumber.

© JOHN MOWERS

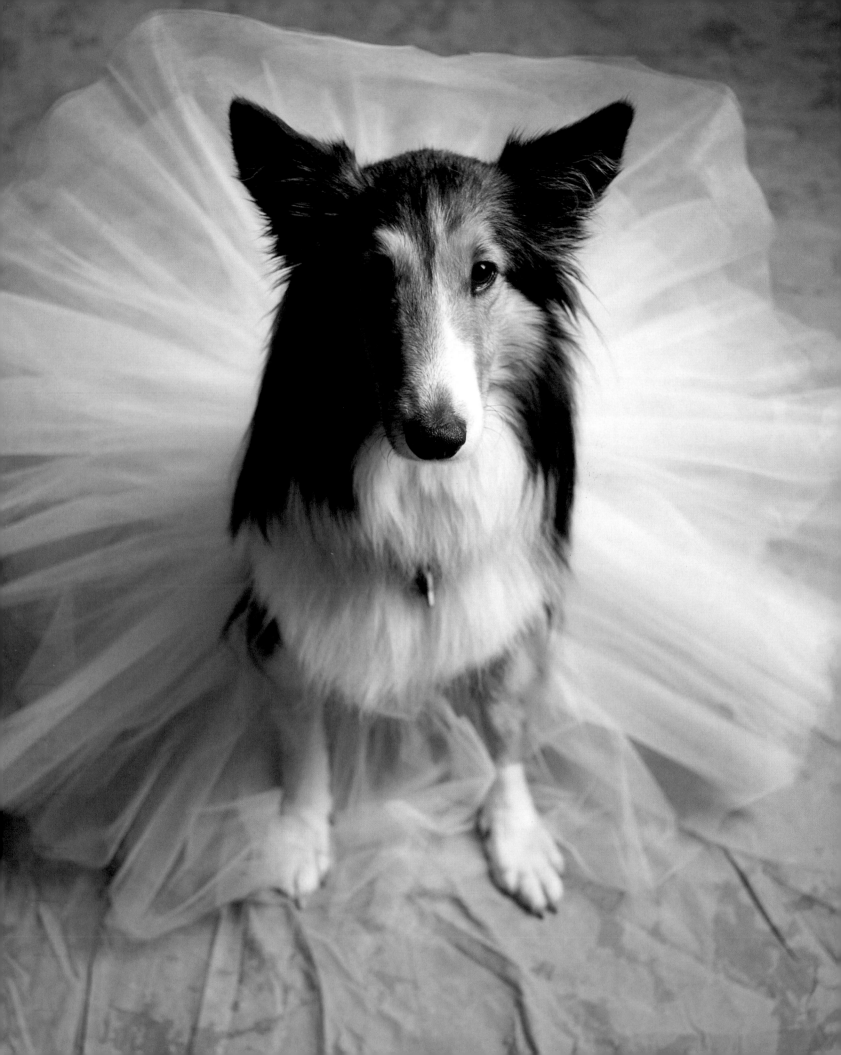

Working Through Creative Blocks

"NO SOONER IS MY HEART STRUCK THAN A SWITCH IS TURNED AND THE LIGHT APPEARS."

–HAZRAT INAYAT KHAN, SUFI TEACHER (1882–1927)

The experience of building a portfolio is often exhilarating, exciting, demanding, and sometimes almost impossible. The impossible moments come when the well of ideas dries up. Many photographers experience times like this whether they are creating new portfolios or not. It's all part of the creative process, and therefore needs to be acknowledged and, yes, appreciated. You must appreciate these blocks because they are sending you a message.

OPPOSITE PAGE The images in this chapter were created after the photographer Eliot Crowley worked through his creative block. They are a direct result of his efforts to create new work. Using Holgas on some and his "magic box" with others, he created images that continue to resonate with national art buyers. This dog in a tutu is a wonderful example of Eliot's free style and sense of whimsy. *©ELIOT CROWLEY*

BELOW This conductor takes us on a ride. We feel as if we are there. The combination of the conductor and the sign bring two elements into one photograph. *© ELIOT CROWLEY*

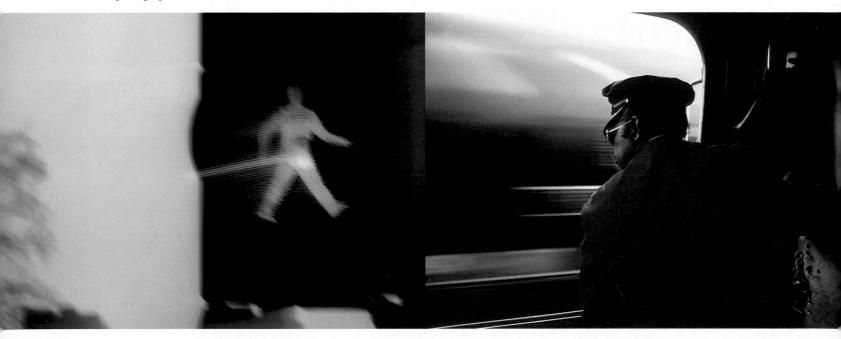

A CASE STUDY

Eliot Crowley is a photographer who experienced a creative block, and used it to fuel a new way of seeing. A successful California-based photographer, Eliot went to art consultant Ian Summers for advice when he became dissatisfied with the work he was asked to produce. Work slowed down, his dissatisfaction turned into depression, and Eliot found himself golfing more than creating.

Ian reminded Eliot that he needed to have fun with photography. According to Ian, the blocks come to artists in the commercial fields of photography, illustration, and graphic design because of a confusion between art and commerce. Their field demands that they problem-solve, which he believes is the antithesis to creation. With problem solving, the impetus comes from the outside, and the artist has to look back to remember what it was like to create from the heart work that is not meant to sell anything. Ian therefore urges his clients, including Eliot, to retrieve the energy they experienced as younger artists.

"I knew that I needed to shorten my learning curve or die," Eliot said. He began to teach himself Adobe Photoshop, a program that was then emerging. "At the same time I began to think about how I would photograph a large group of strangers with a common theme and my magic box idea was born." (Of course, his magic box is a special tool that he keeps to himself!)

Soon after, Eliot and his wife went to Italy, taking his 35 mm camera, a lot of film, and his Holgas, inexpensive, plastic cameras that leak light, allowing for amazing effects. "When I returned I found a client who loved what I was doing with my magic box," he said. "They hired me monthly, and my collections, the Holga, and the magic box continued to grow.

"I decided to build a new book, and take out an ad in KLIK (a national source book). I got calls from the ad and no work from the portfolio. . .I knew that the book I created was just a reworked version and not a new statement.

"I hired a new designer and told her that I wanted to create a portfolio, one that was like no one else's. We chose my Holga work; she designed a new book, an accordion style that allows me to create stories on each page. The book was sent out and the response was tremendous. We went back and created yet another book, a companion portfolio that showcased people. The first art buyer who saw the new portfolios hired me for the biggest job of my life. I was unstuck."

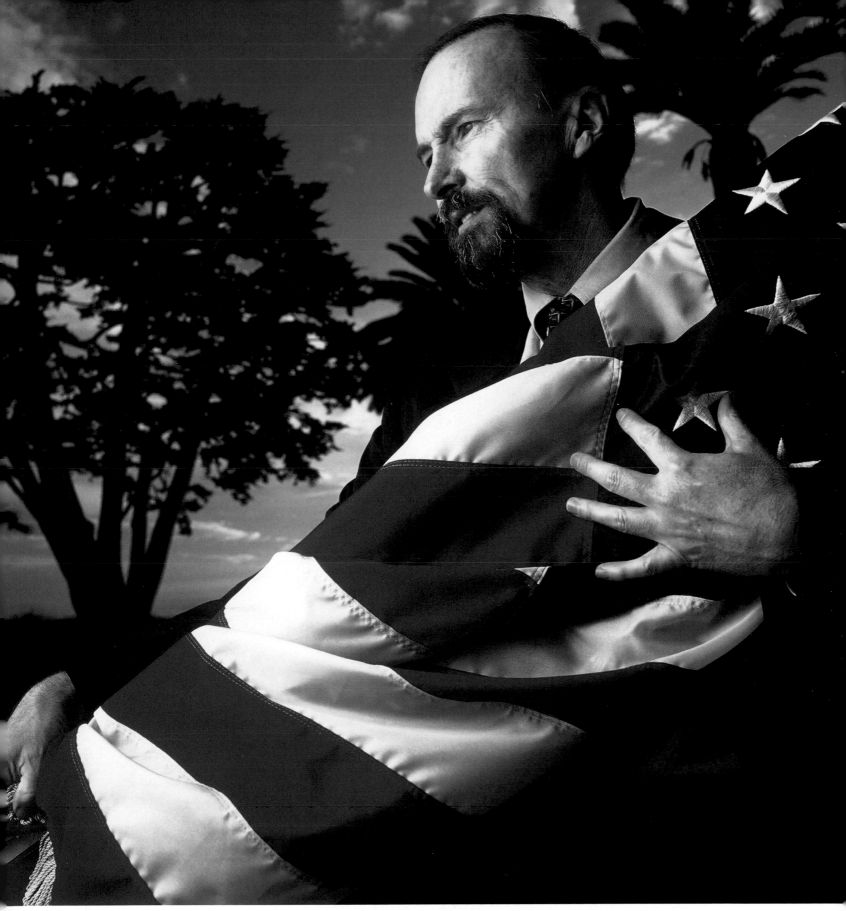

The light and the cropping add to the dynamic imagery that Eliot has created. © *ELIOT CROWLEY*

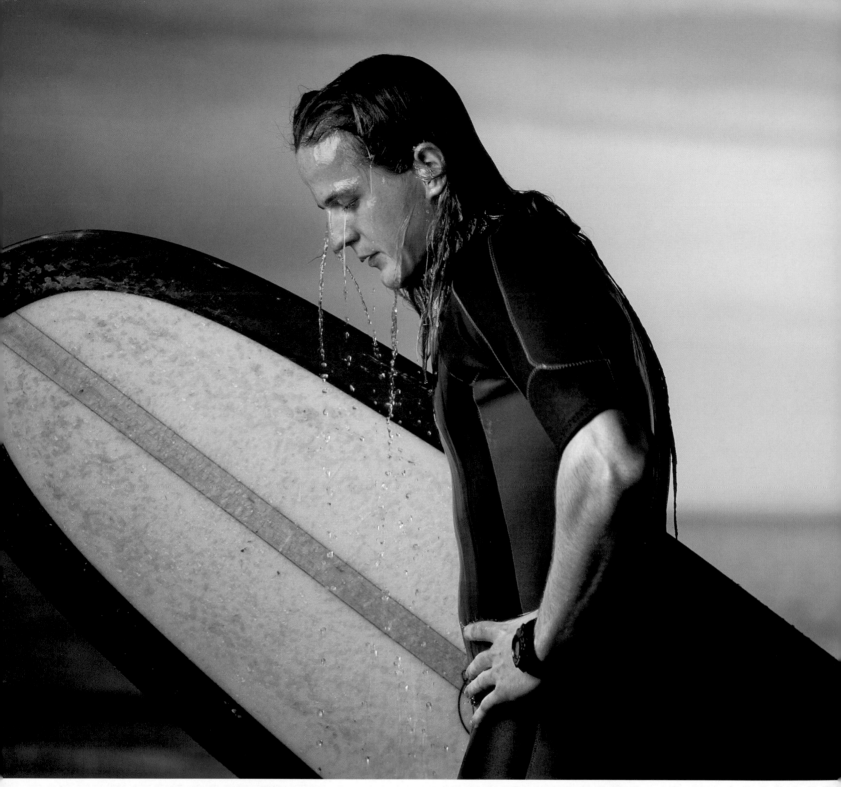

ABOVE An amazingly elegant shot. In the light of Eliot's black box we feel the intensity of the surfer as we "watch" the water drip. © *ELIOT CROWLEY*

OPPOSITE PAGE As with many of Eliot's photographs, we do not need to see the face of the person to get the feel of the moment. © *ELIOT CROWLEY*

tips for working through CREATIVE BLOCKS

Eliot's story is one that many photographers can relate to. In a nutshell he chose not to focus on the negative, and took steps to get out of the rut. And herein lies the answer. Move somehow, someway. Keep shooting.

IF AT SOME POINT, YOU ARE INDEED STUCK, CONSIDER TAKING THE FOLLOWING ACTIONS:

– Use new equipment. Remember how both PhotoShop and his Holga opened Eliot's eyes.

– Force yourself to shoot. Eliot had a camera in his hands all the time; he burned through lots of film. It did not matter what he was shooting. He was shooting just to shoot.

– Get support. Eliot got it from his wife, and from Ian Summers and his creativity workshop, Heartstorming Circles.

– Collaborate with designers and consultants, and build new portfolios.

– Allow yourself to be a student once again. Eliot learned that failing was part of the process.

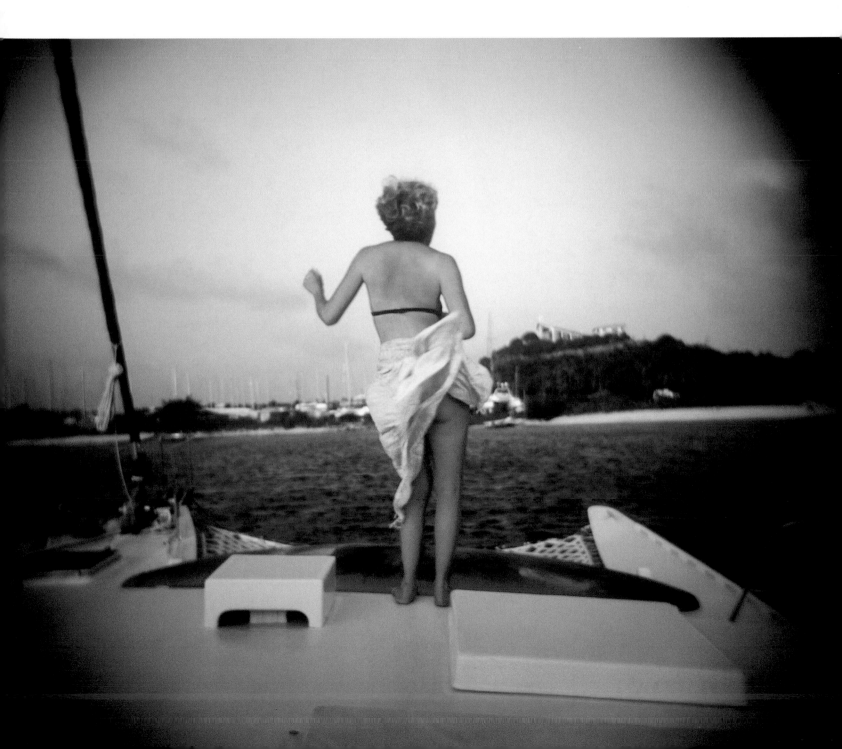

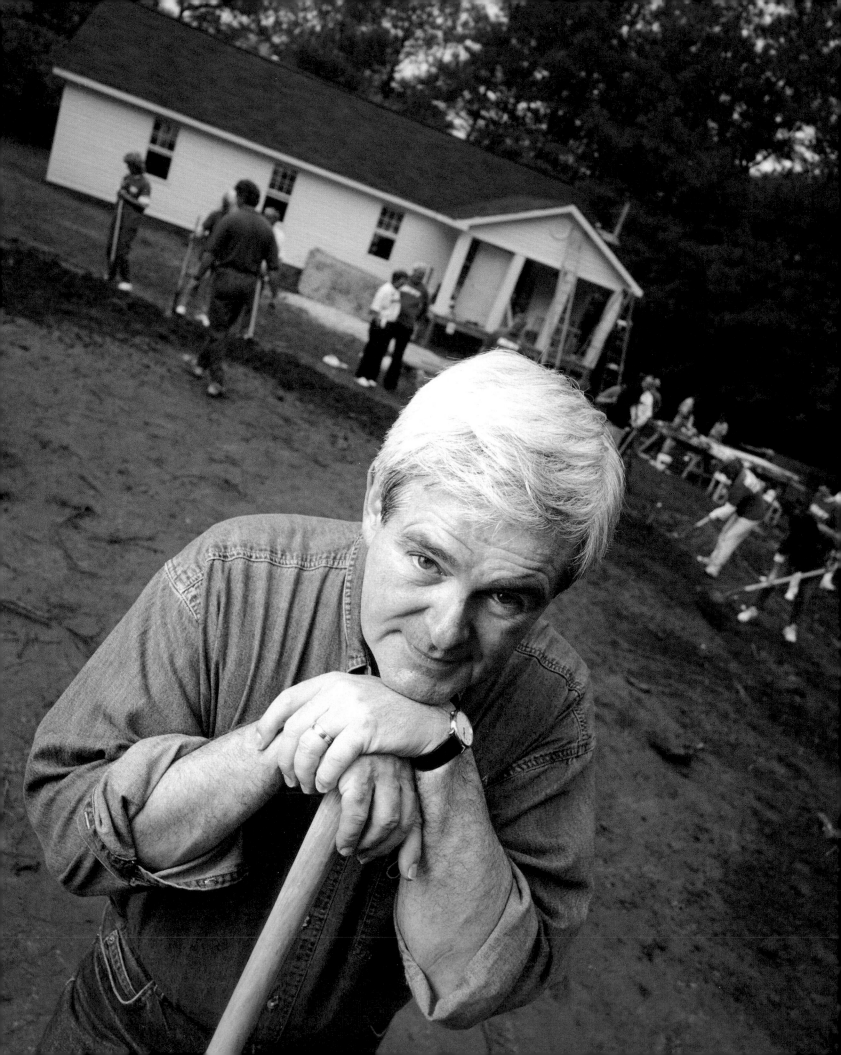

Performing a Final Edit

DETERMINE THAT THE THING CAN AND SHALL BE DONE, AND THEN WE SHALL FIND THE WAY.

—ABRAHAM LINCOLN (1809–1865)

A portfolio that sells is a tight, well-edited book. A final edit is the step in image selection that breathes life into your positioning statement. Your vision will have changed during the process of building your portfolio.

This is the place to weed out the "safer" images. You must be totally focused, as it is here that photographers have the hardest time sticking to the point.

OPPOSITE PAGE The photograph of Newt Gingrich is a great example of the importance that the environment can play in Mark's images.
© *MARK ANDERSON*

BELOW Shot with a panoramic camera, the swimmer combines color graphics and a sense of the environment, key Anderson tools.
© *MARK ANDERSON*

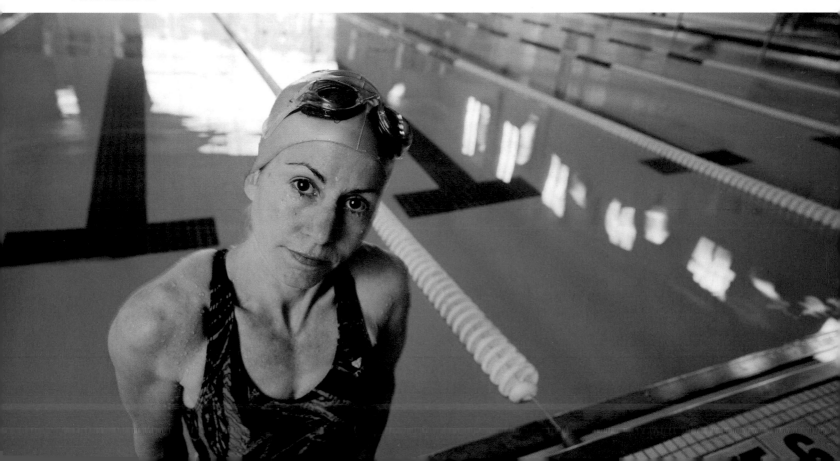

step-by-step EDITING

1. Take out your positioning statement and read it several times.

 Be sure to make note of the specific words that describe your style of shooting (in the moment, people as props, urban youth lifestyle, soul portraits, action, cutting edge, beauty and elegance) and the tools you use to create your images (selective focus, intense color, layered or textured light, locations, models, and props). Keep it next to you as you review all the final choices for your book.

2. Lay out all of your images on a large surface. At this stage, you're probably working with work prints, so use the floor if you need to. It helps to be able to view all of your images at once. Surround yourself with them. This may become one of your favorite stages of portfolio development as all the months of effort are laid out before you. Relish this moment and view what you have created.

3. Play "client" as you make immediate choices. Pretend you're the client reviewing your portfolio. You need to critique your own photos, and part of that process is to ask questions. You can refer to the questions posed on p. 10. Refer to your positioning statement and see if your images speak to your message as a group. By playing "client," I often come up with new words to describe the work.

4. Make immediate discards: While you review all the images side by side, you will be able to identify easily those that are weaker and poorly conceptualized, as well as images that duplicate an idea. If you have to choose between two images, pick the one that is a stronger example of your vision. That way you can compare them to the rest of your images. It becomes obvious at this stage which images need to be included.

5. Final Selection: View all the remaining images. Step back into the role of photographer and look at each image. Once again, compare each image to your positioning statement.

As you choose each image simply pile them all together. Add them to the choices you made in Step 3. Once the two sections are combined take a last look for duplicates and then lay out all of your choices, preparing for final pagination.

Photographer Mark Anderson went through the process of a final edit. Mark is an Atlanta-based people and location photographer for national editorial clients. He sought to develop new clients in the corporate and editorial fields.

His final selection was made to fit his positioning statement: "Mark Anderson carefully considers location selection, composition, and color in creating images that portray a connection with people. Mark doesn't simply photograph subjects, but captures 'people in their element.'"

Mark began his final edit with many more images than he ended up with. Ultimately, he chose twenty. The images that follow are a sample from his final book. Some were created especially for the portfolio and others on editorial assignment for publications. Each image contains a different combination of Mark's usual tools, but they all exhibit his vision.

The environment in this shot is filled with information about the subject, who remains the focus. © MARK ANDERSON

Humor and personality are combined with Mark's usual tools, graphic composition, and camera angle. © MARK ANDERSON

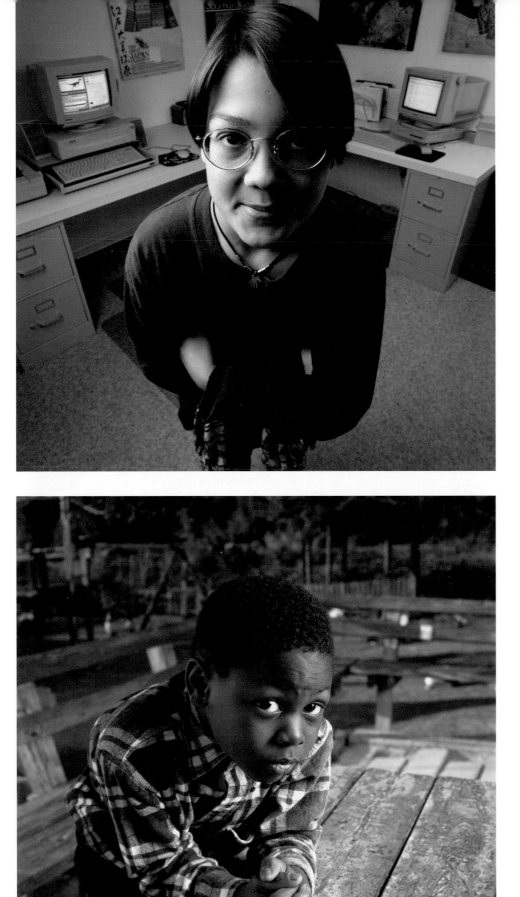

Mark creates an image of an executive that truly captures him in "his element." © *MARK ANDERSON*

how much is TOO MUCH?

Only include the number of images you need to communicate your positioning statement. On average, the portfolios I have worked on contain 15–20 images. However, I have developed portfolios in a storybook format (see Chapter 8) with up to 30 images.

I recommend that in a single-image book you consider no more than 15–18 images. More than that is usually too much.

Art directors and other clients are professionals whose job it is to get a message across quickly, whether in a turn of a magazine page, in a 30-second TV spot, or in an annual report spread. They are also used to looking at many portfolios. They can get your message easily if it's there to get.

Mark Anderson uses composition, lighting, and props to capture his subjects' personalities, such as in this outdoor environmental portrait. It fits in with the other portraits included in his portfolio.

© MARK ANDERSON

Arranging Your Portfolio

ALL LIFE IS AN EXPERIMENT. *–RALPH WALDO EMERSON (1803–1882)*

Pagination is an art. Many photographers give little thought to the placement of images. This is a mistake, because a book is much more successful when conscious thought is applied to the sequencing of images. You can build a viewer's interest or evoke an emotional reaction simply through the order in which images are presented.

Once 75 percent of your images are chosen, you can begin to consider the format of your portfolio. There are many formats to choose from. It is your job to view them and choose one that will showcase your work without underwhelming or overwhelming your images.

OPPOSITE PAGE AND BELOW Irene Spector is an editorial travel photographer. She chose a single format for her portfolio, as she wanted the viewer to take the time to look at each image. On the left is a photo of fresh cod, taken in South Greenland. Below are two boys at the edge of Blue Lagoon, Iceland. Her trips there were planned specifically for portfolio development. Irene's lovely style speaks for itself. Color, light, and graphic composition are key ingredients in her shots. *© IRENE SPECTOR*

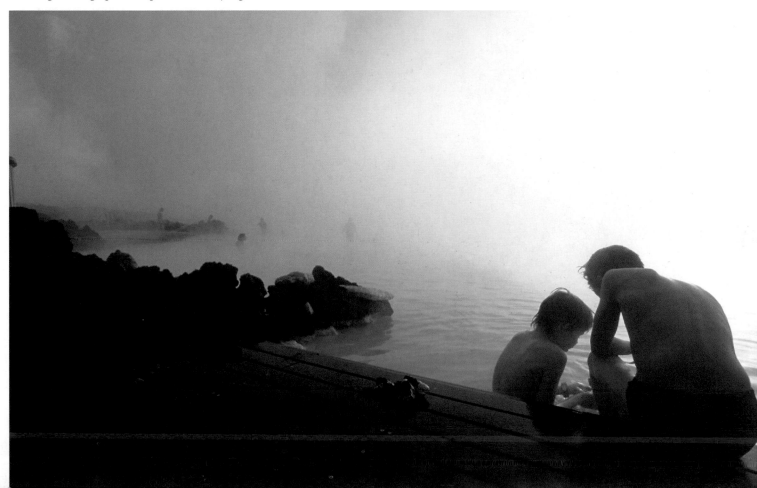

CHROMES VS. PRINTS

Before you work on pagination, you need to decide whether you're producing a chrome book or a print book. Pagination just means the order and placement of your images. A few years ago, you had the choice of showing prints or chromes. Nowadays buyers don't look at chromes. The majority of buyers are under 35 and they're more used to viewing images in print format. The photography market has changed that much.

Personally, I love the color, the vibrancy, and the immediate connection of chromes, but I understand why clients dislike them, since they need light boxes and a loupe, and only one person at a time can view them. Because of the volume of portfolios clients receive, they often overlook chrome portfolios.

The factor that clinched it for me was the introduction of art buyers at most ad agencies in the mid-80s. Once the art buyers became the major contact for photographers, and there was an extra layer between the photographer and the decision-maker,

it was critical that portfolios be easily accessible. If you lost the art buyer you might never get to the art director, the true decision-maker. Creating a format that worked for these key contacts is just good business.

As if that were not enough of an incentive to go to a print format, it became more commonplace to drop off your portfolio instead of presenting it in person. Suddenly photographers were just sending their book in and in most cases not even meeting with the art buyer, photo editor, or graphic designer. Photographers found that chrome books and printed portfolios that were not bound were impractical. Showing an unbound book led to images being placed out of order and created an opportunity for images to get "lost" or left behind.

Technology gave the printed book a huge boost as digital printers began to replace the darkroom. Digital printers offer photographers ease in playing with papers and image placement.

This shot was taken from an old logging vehicle used to navigate the rough and often washed-out Canol Road in the Yukon Territory of Canada. It is a strong image that enforces Irene Spector's position as an outdoors/travel photographer with a strong vision. © *IRENE SPECTOR*

Irene shot this iceberg off Devon Island in Nunavut, Canada's newest territory. © *IRENE SPECTOR*

choosing the RIGHT LAYOUT

Most photographers display a single image per page, but I encourage you to explore all options before deciding which works best with your vision. The three main options are: single image, double-page spread, or a storytelling approach. There is no type of photography that works best with any one format.

VIEW ALL OF YOUR OPTIONS, AND ASK YOURSELF THE FOLLOWING QUESTIONS BEFORE CHOOSING A PAGINATION FORMAT THAT WILL WORK FOR YOUR PORTFOLIO.

1. Is there a relationship between my shots?

2. Are my images very involved, with lots of components that create a need for them to be seen individually?

3. Can I easily see a color connection between several images?

4. Am I in a market (editorial, corporate) where it makes sense to show my images to prospects in a storytelling or in a single image format?

5. Do I have images that automatically feel as if they are meant to be together?

After you have reviewed your images and answered the questions, decide which format you will experiment with.

SINGLE IMAGE

Single-image pagination involves placing one image on each page. As the viewer turns the page, he views a single image on the right- or left-hand side. Many photographers prefer this style of presenting, as all of the viewer's attention is momentarily focused on that single photograph. The idea is that the viewer looks at each image in and of itself, not in connection with any other shot. This style works with almost any type of photography. While this is a fine way to organize your book, it is not the only option.

DOUBLE-PAGE SPREAD

The double-page spread is used when there are photographs that have a direct relationship to each other. The relationship can involve a strong and consistent color palette, a subject connection, or a visual play between two images. The use of this format, when done well, strengthens the overall feel of the book, as the images relationships to each other become another factor in the overall feel of the portfolio. The format provides more depth for the viewer, as the photographer is exhibiting not only his/her work but also an understanding of how images work together. Many clients use images in combination with each other in annual reports, long editorial pieces and 2-page national advertising spreads.

Choosing this option gives you the opportunity to lay out your portfolio in a manner that provides additional context for the viewer.

Steve Begleiter, a Philadelphia advertising photographer, chose a double-page format for his book. "I wanted my portfolio to read like a photography book. I always like juxtaposing images, and creating a portfolio with spreads allowed me to create a visual flow." Jake Armour of Armour photography is a fan of the double-page spread. "It allowed us to tell our story. A spread gives us the opportunity to show contacts how it all comes together."

OPPOSITE PAGE To create a double-page spread book with Jake and Hope Armour, we started by editing existing images. Then Jake and his team went to work creating new shots that would be paired up with the images that we kept. The idea was to create new images that gave the viewer even more visual information about Jake as a photographer while being dynamic images in and of themselves. View the images and I think you will agree that Jake's images are individually dynamic and bold, and as pairs really belong together.

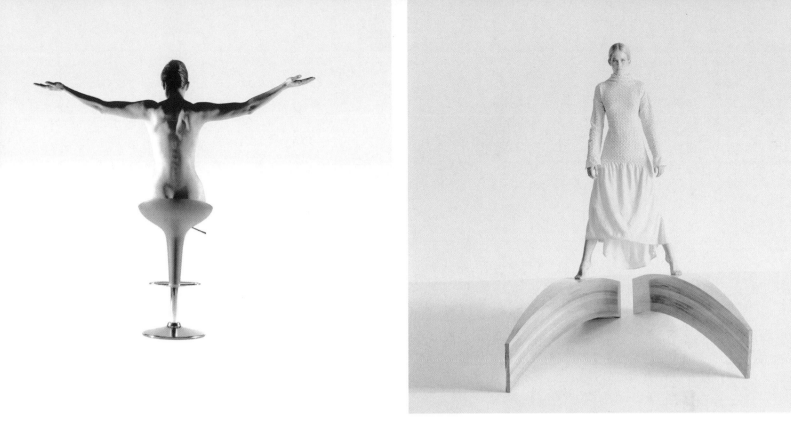

The woman seated in a chair was already in Jake's portfolio. The new image of the woman standing was shot to match. © JAKE ARMOUR

The shot of the Sony headphones was also in his portfolio. He photographed the Calvin Klein belt to match. Using these two images, Jake is able to appeal to both the consumer electronics and fashion accessories markets. © JAKE ARMOUR

The image of the woman and the bag existed before the shoe shot. When we were looking to match shots for spreads, Jake decided to shoot the man with the shoes. It is perfect complement to the bag shot. © *JAKE ARMOUR*

USING THE SPREAD FORMAT

The award-winning, Minneapolis-based Armour Photography, headed by photographer Jake Armour, is one of the most successful studios in the midwest. It services an array of clients, including Target, and a host of advertising agencies. Recently, I worked with the studio developing a new portfolio for a national launch. Jake, and his agent, Hope Armour, chose a spread format.

"We decided to use the spread format to promote our national branding because it presents a clearer story of our photographic vision—which includes people and objects—than do individual pages," said Hope. "With spreads, each image has a partner that brings continuity to the book and reinforces our photographic style. The spread takes the viewer on a short visual journey and demonstrates a progressive expression of the photographer's visual approach."

Jake and Hope created new images to match existing shots. "The images are paired together based on common elements," she said. "They may have a similar graphic style, type of lighting, background, content, or energy. They often share several of these elements.

"Images were created specifically with its companion in mind. However it was important that the quality and integrity of the new image worked just as well on its own."

The end goal for the portfolio was to let the Armours' current and potential clients see how the photographer—Jake—sees. Hope concluded, "The images themselves speak to Jake's unique visual approach, while the presentation of the book speaks volumes about our aesthetic sense and also reflects our attention to detail."

STORYTELLING APPROACH

A storytelling approach involves placing more than two images on a double-page spread, or creating a multi-image spread. This is one of the most exciting layouts and one of the most difficult to do well. In a storytelling book, all images are placed in a manner that looks random, but in fact is carefully thought out.

A portfolio that follows the storytelling approach can start with one image on the right-hand page (left-hand page blank), followed by a spread with one image per page, then a spread with a single image, and so forth. The layout is determined by the needs of the narrative, which the photographer establishes.

Susan Bourgoin of Visual Cuisines is a talented food photographer who was interested in showing potential clients her storytelling capabilities as well as her ability to create a single, memorable shot. While the images that follow are not an exact replication of the book order they will give you an idea as to how the pagination worked.

RIGHT The pomegranates on their own lead the viewer into seeing food as still life.
© SUSAN BOURGOIN

BELOW A storytelling approach allows you to combine a still life (wine bottles) shot with a people image.
© SUSAN BOURGOIN

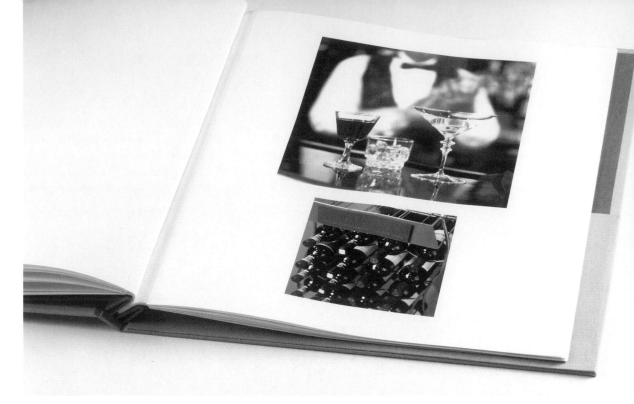

ABOVE Showing two images together allows the photographer the opportunity to combine colors and textures. © *SUSAN BOURGOIN*

BELOW The next image shown by itself is impactful and lovely. © *SUSAN BOURGOIN*

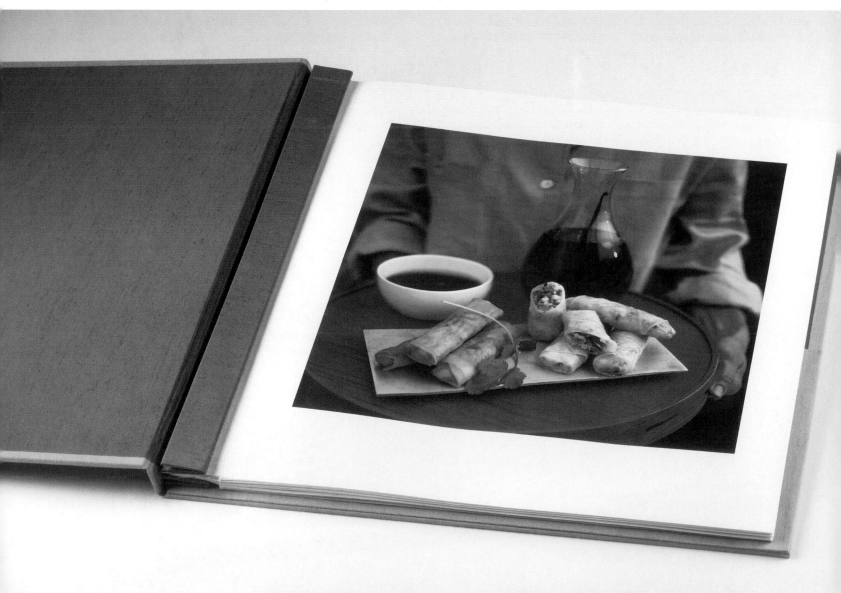

a portfolio exercise: PLACEMENT OF IMAGES

Knowing which pagination format you have chosen, take all of your final edit images and lay them on a surface. Now step back and start to play. Choose one image that immediately catches your eye. Usually it's an image that contains many of the visual elements that you listed in Chapter 1. Put it in the beginning of the book and start looking to see which image should follow. Look for a relationship between this image and the next. As you determine which images should be together, you will note that color; subject, emotion, and graphic composition are the tools that create a flow from one image to another. For me, the images start speaking at this point. If I simply step back, my intuition tells me which images belong with each other.

As you place one image after another, notice how they look side by side. Do they flow together visually? Once the order feels right, leave it alone. Keep it spread out and revisit your layout periodically for the next few days, making changes or simply experimenting each time you return. The process of "sitting with" the image placement is key. It's not unusual for you to feel as if you arrived at the perfect pagination, only to look again a day or so later and discover a new order that works better. Pagination is an art, one that requires patience, a sense of play, and the ability to see your images in the context of the entire portfolio.

John Soares is one of my very favorite photographers. Sure he is a great guy, but as a talent he is fearless. John's portfolio is a double-page spread book, a format that enables him to marry photographs creatively. His vision is about form, fun, and seeing every image as an event.

RIGHT This image opens the book. For John, it brings to mind a fun and productive shoot, and therefore is a token of success. The shadow leaping over his name is a metaphor for taking a leap of faith.
© JOHN SOARES

ABOVE, LEFT AND RIGHT These were shot for CD covers, for the same record company. They reflect the same sensibility and sense of humor. Their color palettes work well together. © *JOHN SOARES*

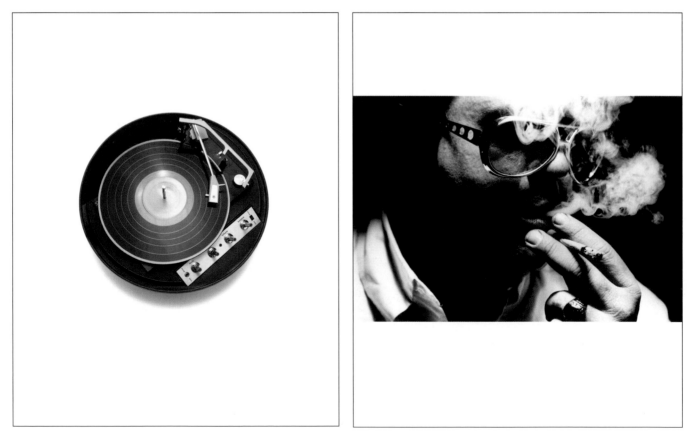

ABOVE, LEFT AND RIGHT John continues the to pair up still life images with people. The Elvis figure was shot for a promotional book, which told the story of two people who mysteriously encounter Elvis in the Nevada desert. The record player, circa 1970, is a good thematic match. © *JOHN SOARES*

LEFT AND BELOW John shot DJ Dave Ralph with a ring-light, which leaves no shadow on the subject. However, it burns a white ring onto your retina for about 20 minutes, which may be why Ralph's eyes are closed here. This went well with a shot John took of a bowl of prosthetic eyeballs. © *JOHN SOARES*

Production Choices

IF ONE ADVANCES CONFIDENTLY IN THE DIRECTION OF HIS DREAMS, AND ENDEAVORS TO LIVE THE LIFE WHICH HE HAS IMAGINED, HE WILL MEET WITH A SUCCESS UNEXPECTED IN COMMON HOURS.

–HENRY DAVID THOREAU (1817–1862)

Your next job is to choose the paper stock for your final prints, and determine the size your images. As you go through this chapter, think of the mantra "the outside reflects the inside." You have been working from the inside out, and now the physical format is ready to be created.

There are many options for pre-made books, as well as books that are specially created for you by a bookmaker. (Do not confuse handmade books with homemade ones.) Read through the following suggestions and ideas, and remember, there is no one way to build a book.

LEFT AND OPPOSITE PAGE Despite the popularity of digital photography, Tom Johnson is still religious about photographic prints. The results he seeks for his editorial portraits–more texture, richer tones, and greater tonal separation –are attained through the traditional darkroom process.
© TOM JOHNSON

DIGITAL VS. THE DARKROOM

If you are doing a print book, the first decision you need to make is whether it will be a digital or dark room production. Of the 50 books I created this year, only one was printed in a dark room. Digital prints are an excellent way to go and many photographers are choosing a printer over the darkroom. While making a digital print can often be as time consuming as printing in the dark room, it is easier to make copies once your settings are perfected.

Tom Johnson, a great editorial portrait photographer from Los Angeles, is still religious about photographic prints.

"When it comes to black and white photography, I continue to use my darkroom rather than my digital printer to create prints," said Johnson. "The reason I choose to work in the darkroom is that the image on a silver gelatin print is embedded in the emulsion of the paper whereas on a digital print the image is spray painted on to the paper. As the photographic image is in the emulsion, silver gelatin prints have more texture, richer tones, and greater tonal separation compared to digital prints. Even with the very best digital outputs I see a difference. The difference can be subtle and sometimes only noted upon close inspection. For some photographers this difference is not worth the trouble and inconvenience of a traditional darkroom, yet for my work the difference is great enough for me to remain standing hours upon hours in my darkroom inhaling chemicals."

OPPOSITE PAGE AND ABOVE © TOM JOHNSON

Marc Norberg, one of the top annual report shooters in the U.S., uses both formats in his studio. "It doesn't matter whether we use a digital or conventional process. In our business, the concept is king. We can provide silver or platinum prints if necessary or scans of finished art in digital files if it's required. It depends on what's appropriate for illustrating the idea in a fashion which best suits the need."

If you choose to create a digital portfolio and do not currently have knowledge of the equipment, give yourself plenty of time to learn. The learning curve can be quite steep.

BELOW AND OPPOSITE PAGE Marc Norberg is a highly respected photographer, known for his sensitive, intuitive, impactful portraits. The author of Black White and Blues, the award-winning 12-year visual study of blues artists, Marc is now working on a book on the American landscape and a book on issues relating to mental health. He experimented with digital prints when taking these images for his new portfolio. © *MARC NORBERG*

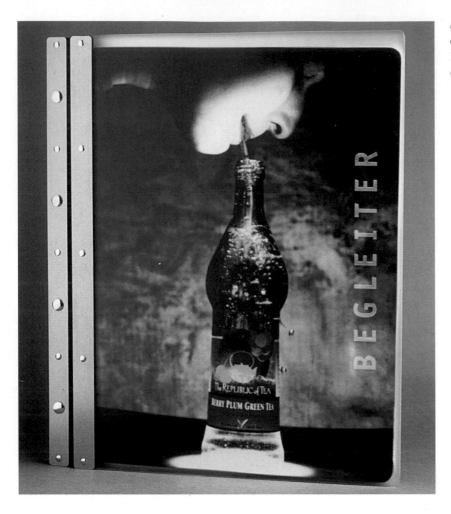

PAPER CHOICES

The layout of your book may help you to decide which paper to choose. If you have chosen to use the double-page spread or storytelling format, you want to be able to print on both sides of the paper. Years ago when photographers created books everyone had plastic sleeves. It was not important to choose a two-sided paper as the images simply were slipped into the sleeves and created spreads. Plastic sleeves however, also created distance, caused reflection, and seemed to attract every animal hair on the planet. Thank goodness most artists have retired those old warriors!

AS YOU LOOK FOR PAPER, YOU WILL SEE THAT MOST CHOICES FALL INTO THE FOLLOWING CATEGORIES:

- Mat

- Glossy

- Watercolor

Double-sided digital paper is available in mat and watercolor versions (see Appendix).

When choosing paper, you must consider your images. If an image conveys warmth and emotion, a mat or watercolor paper may enhance it. If your images are colorful, graphic, and bold, then a mat or glossy surface might be preferable. Used well, paper becomes another textural tool that helps to deliver your visual message.

Steve Begleiter created a portfolio of photos shot in infrared. Eager to find a paper that would enhance his process, he chose to print on Kodak's Color Metallic. The effect is stunning. It adds another level of sheen and dimension to images that were already quite dramatic. "I was looking for a paper surface that could best represent the 'punchy' colors I use," he said. "Kodak Color Metallic paper had all the qualities that I was looking for. The highly reflective surface of the paper gave the appearance that my images were almost three dimensional, jumping off the page. The durable paper made it perfect for presentation. I no longer had to put my images behind plastic, dulling the color impact, to protect the image. The paper does not tear and fingerprints easily wipe off."

a portfolio exercise: THE PAPER TEST

In order to make a final decision on a paper choice, take the Selina print test. Choose three images, one dark, one light, and one midtone. Print all three on your two favorite surfaces. Use three samples from different manufacturers, as you will notice subtle changes from brand to brand.

Make sure to mark the back of each image with the paper type and manufacturer. After all the images are printed, lay each of your three photo choices in a horizontal column. You should have six prints of each three images for a total of 18 prints. Making sure to only look at one image grouping at a time, choose the print that works best. When you have gone through all three images, look on the back and you will discover (9 out of 10 times) that you have chosen the same paper for all three, or at the very least for two out of three images. Now you have a paper that works consistently with all of your images.

If you have chosen two or three different papers and find that you are in a quandary, start to look at the dark and light parts of the prints. Is there one paper that seems to handle the images better? Look to see if one paper is whiter or more yellow than another is. With watercolor paper, check if there is more rag in one paper than another. Does one paper show details more than another does? View your images and decide which paper speaks to your photography, which one enhances what is already there.

Once you have decided on a paper, make sure to order all you need when buying the paper. Some of my clients have had to start all over as they did not buy enough paper and the manufacturer decided to stop producing the line they were using. In addition, there are sometimes color shifts that happen from one paper lot to another.

RIGHT This image of butterfly weed and asters worked beautifully on two different kinds of paper. Rich experimented with a smooth paper, Epson Professional Enhanced Matte Paper, and a textured paper, Hahnemuhle fine art paper.

© RICH POMERANTZ

determining the SIZE OF YOUR IMAGES

Whether you have chosen the single-image, double-page, or storytelling layout, you need to decide the size of your images. If you are doing a single-page layout, the image size will most likely be consistent. A double-page spread and storytelling approach calls for variety in image sizes.

WHEN CONSIDERING THE IMAGE SIZE TAKE INTO ACCOUNT THE FOLLOWING ELEMENTS:

1. MOOD: Are your photos quiet in feel? Should they be small and the book intimate?

2. USE OF COLOR AND GRAPHICS: Are your images humorous, graphic, or extremely colorful? Would big be better?

3. SUBJECT MATTER: Do you have a lot of detail in each photograph? Are there lots of visual elements in each shot? Often, in a small image details and the feel of the photo are lost if there is not enough room for the photo to be seen.

Next you must decide whether to use borders or bleed. Bleed images—which use the entire area of a page—work best in a double-page book spread. Single-image books often call for borders. However, I have created very effective single-image books, mixing bleed and border images. If you are not sure what style works for you, create a visual example of the styles you like using the same image and position them on 2–3 sample pages. You will quickly be able to see what works for you. Decide which images should dominate. This can be achieved by giving it a bleed page. The second shot is sized depending on its importance to the companion image and to its content. I play around with placement, sometimes putting shots close to the edge of the page, on the bottom, and smack in the middle.

Not every spread needs to have a major and minor image. Sometimes images hold equal importance. When they do, consider sizing and positioning them similarly.

Size and placement is a very intuitive process. Every shot, every spread, needs to be handled individually.

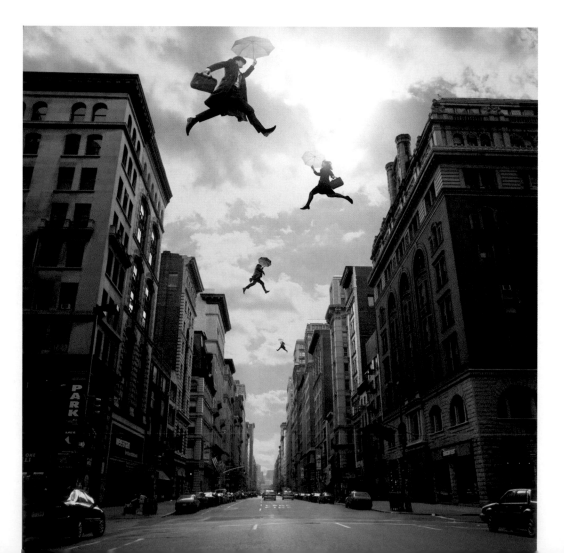

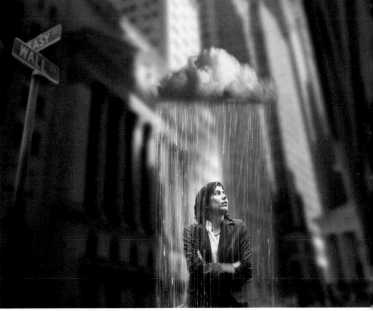

ABOVE, RIGHT AND OPPOSITE PAGE Mark Beckelman is a storyteller who creates worlds that don't exist for advertising, corporate, and editorial markets. He uses Adobe Photoshop to create images filled with humor and fantasy. As you can see, Mark's images have many components, and lots of detail. It is important that the viewer be able to see the images well. For that reason we chose a single-image portfolio format. This format calls for one image per page, allowing the viewer to fully focus on each visual.

© MARK BECKELMAN

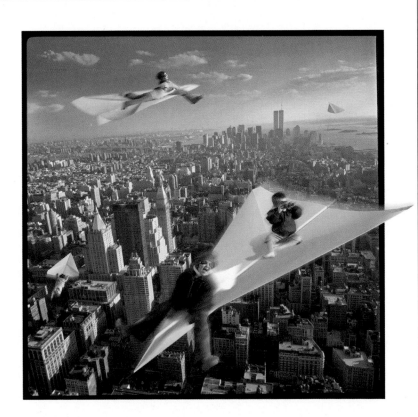

The Physical Portfolio

**THERE IS SOMETHING IN EVERY ONE OF YOU THAT WAITS AND LISTENS
FOR THE SOUND OF THE GENUINE IN YOURSELF.**

—HOWARD THURMAN, AMERICAN THEOLOGIAN (1900–1981)

You are finally here! Now you can choose the housing for your portfolio. You can choose from a premade or handmade book, a bound or post-and-bound book (with removable pages), and various other formats, including an accordion-style portfolio. Once again, your images should determine your choices.

LEFT Eliot Crowley wanted to create a distinctive format for his images. The accordian-style format he chose allows viewers the opportunity to turn the page and see each spread individually or opening up the book completely to view one continuous stream of images. *© ELIOT CROWLEY*

OPPOSITE PAGE The box created to house Zave Smith's new portfolios. Angela Scott built it using purple Asahi Silk. The color was specifically chosen to represent the emotions that Zave captures.
© ZAVE SMITH

post-and-bound PORTFOLIOS

A post-and-bound portfolio has screw posts built into the spine of the book. It is the most popular kind of portfolio. The screw posts allow for images to be removed. While there are some companies that make pre-made post-and-bound books, most do not include book tape, a fabric that adheres to each page, applied by a bookbuilder, that allows it to lie flat. They attach your digital or darkroom printed images to book tape and the book tape is inserted into the holes in the books spine. It is worth your time and money to have this done professionally.

BELOW Jerry Hart is a corporate shooter from Oregon. His images are housed in a single-image, post- and-bound book, designed and built by Nicole Anderson (see Appendix). The pages turn easily and lie flat, a critical component in any portfolio! © *JERRY HART*

accordion-style PORTFOLIOS

Accordion books rely on a hard front and back cover and contain images that appear to be printed on a continuous piece of folded paper. In fact, your photos are taken to a bookmaker who adheres individual pages together. Each page that is turned is in fact two pages. By pulling the portfolio out, you get one continuous stream of images.

This format works well for double-page spread and storytelling books, but is unnecessary for single-image books. An accordion-style book does not allow for new images to be inserted. Many photographers want to put new images in their portfolio just about as soon as they are created. I beg photographers to avoid this. If there are new images, put them aside for your next book. With this in mind, the drawback to accordion books seems to disappear.

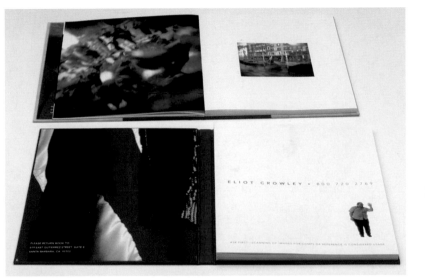

Eliot Crowley's accordion stylebook is a perfect choice for his images. Eliot has created two separate books, both of which are housed in a color coordinated box. The physical format is distinct and unusual yet classic and tasteful, words that I would also use to begin to describe the work that Eliot creates.

ABOVE Images appear on the inside cover. Each page can be individually turned or the viewer can choose to spread out the book completely. © *ELIOT CROWLEY*

TOP, RIGHT Accordion books lie perfectly flat when closed and Eliot's name is very prominent. Eliot's name, phone number and address are worked into the design. © *ELIOT CROWLEY*

BOTTOM, RIGHT Eliot's complete system involves two books, a matching box, and a travel bag in which to send the portfolios. Bright colors bound with black create a tasteful yet bold statement. © *ELIOT CROWLEY*

unbound PORTFOLIOS

If you are eager to not have a book format and would like your images seen individually and separately then you will be showing images one by one. They will not be bound into any type of book.

While this format can work quite well, it creates two problems. You cannot guarantee the order of the images, and there is more wear and tear on the photos.

BELOW Anthony Wood is a people photographer from Philadelphia. He chose a heavyweight watercolor paper for his moody, elegant photographs. He was interested in having individual sheets of paper that people could hold, touch, and feel. He was ready to reprint when needed and felt that being able to put an actual print in a viewer's hand was worth the time he would spend reprinting. © *ANTHONY WOOD*

RIGHT Opting to create a format that would allow him to present his images individually, Anthony turned to Angela Scott, a professional book builder (see Appendix). Angela created the unbound format seen here. The flat book holds individual prints that are printed on heavyweight watercolor paper.
© *ANTHONY WOOD*

ABOVE, LEFT The leather box (on the left) houses the flat book on the right of the image. Both the book and the box have Anthony's logo on the front. © *ANTHONY WOOD*

ABOVE, RIGHT Angela built a well in the outside box for Anthony's tearsheets. When you open the box you see the flat book and as you pick up the book you see the tears nestled below. The effect is personal and professional and perfect for Anthony's needs.
© *ANTHONY WOOD*

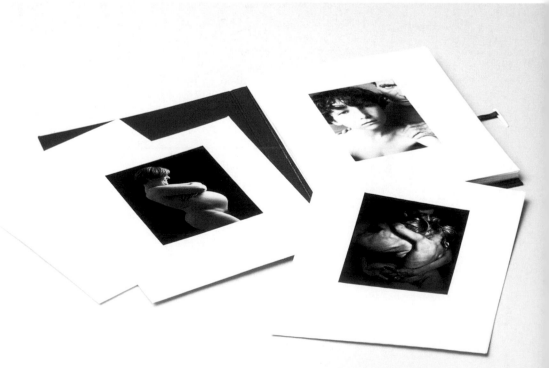

Years ago when lamination was popular, there was little concern about the images being damaged from handling. Each image was laminated which protected the images, and spills were easily erased. While lamination is still available, it is less popular. However, it can work for certain photographers with particular visions that call for it, as in the case of Michael Indresano.

Portfolios that contain graphically strong and color-saturated visuals may work well as laminated prints. Portfolios that are about moments, emotion, connection, and other evocative feelings would not do well as laminated prints. The cool feeling of lamination, the reflection, and simply the layer of plastic between the viewer and the image do not jive with an image that is about warmth and mood.

BELOW Boston-based photographer, Michael Indresano chooses to show laminated prints. As Michael's work is very graphic and slick the format works well. As a viewer opens Michael's black leather box they immediately view an extensive client list. The laminates are nestled in the box on the right under a tearsheet book. Images with borders are mixed with bleed shots quite successfully. © *MICHAEL INDRESANO*

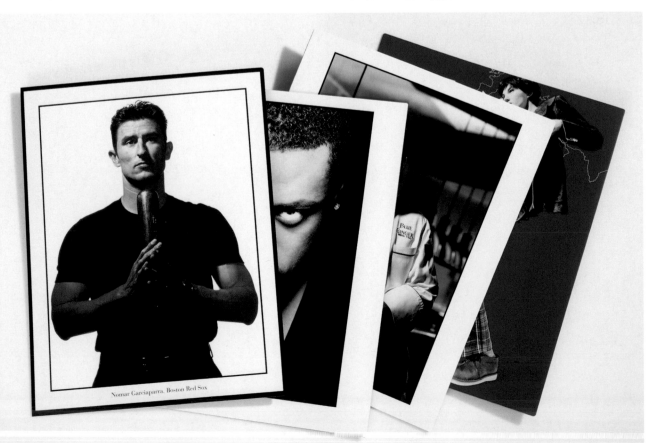

ABOVE, LEFT Portfolio box with tearsheet book.
© *MICHAEL INDRESANO*

ABOVE, RIGHT Box and laminated prints.
© *MICHAEL INDRESANO*

LEFT Laminated prints.
© *MICHAEL INDRESANO*

COVER OPTIONS

Today, very few photographers use black portfolios. Custom covers are becoming more and more popular. Designing the cover is of my favorite parts of putting together a new portfolio.

Once you have your format chosen you will need to decide on the type and color of material that will cover your book and/or box. There are many fabrics, including leather, silk, and cotton to choose from. In addition, plastic, metal, and wood-based covers have become popular. The array of colors can be staggering.

In order to begin the process you will once again turn to your images to give you clues. In addition, you can refer to the colors of your corporate identity as a guide. The idea is to brand your portfolio, your corporate identity, and your marketing tools together. If you are happy with your corporate I.D. and feel that it truly reflects the attitude of your images, seek to use the colors in your I.D. as the colors for the covering on your book. Make sure that your corporate colors speak to the images and do not clash with the feel of the imagery.

If, however, the colors in your I.D. do not speak to the images, work with your book designer, consultant, or graphic designer to come up with a palate of colors that will work.

If you are purchasing a pre-made portfolio, your choices will be limited by the company you choose to work with. Book builders have enormous options available and can sometimes work with fabrics you provide.

BOXES

Most photographers have a box created that will house their gallery books and tearsheet books. If you are not using a tearsheet book (see Chapter 11), a box may not be needed. Personally, I favor having a box that the viewer can open to find a portfolio or two waiting inside. Susan Bourgoin of Visual Cuisines has three books in one box: a gallery book for advertising work (in a spread format), a gallery book for editorial work (in a storytelling format), and a tearsheet book.

Boxes can be made by bookmakers to match and coordinate with your gallery and tearsheet books. The box becomes another design element.

Whether you choose a box or not, do choose a shipping case. The Tenba and Lightware cases (see Appendix) are very popular with photographers as they are lightweight and sturdy and hold up extremely well. Your book or box is simply slipped inside and an airbill put on the outside of the case. While the shipping case is not inexpensive, do not skimp here. The cases are well worth the money.

pre-made or handmade BOOKS AND BOXES

One of your last decisions is whether to buy a pre-made book and box or hire a book designer/builder. There is no one answer for every talent. What you must do is to go back once again to your work and check your budget. Get a feel for the style of exterior that will best highlight and complement your visuals. Are you looking for a style of book that is currently offered by one of the pre-made book companies or are you looking for a more exotic color or fabric?

Look at the type of binding that you feel will work best. Is it important to you that pages lie flat as they are turned? Will plastic sleeves get in the way of viewing your images? Will you want a special format (accordion style)?

If you have answered yes to these questions, then start looking for a book builder, as most pre-made books require plastic sleeves, rarely lie flat, and mostly come in standard styles.

Book builder Nicole Anderson worked with my client Susan Bourgoin of Visual Cuisines to develop a box system that enabled Susan to show two gallery books and a tearsheet book in a single box. Digital prints housed in Japanese Asahi silk speak to today's material options! © *SUSAN BOURGOIN*

One company that offers pre-made portfolios is raising the bar for all other companies. Lost Luggage, started by founder Jason Brown, a graphic designer, combines the best of both worlds. At Lost Luggage there are several pre-made portfolios that you can purchase, including a spectacular acetate line called "Ice Nine" (see Appendix). In addition, you can request a special order book that will accommodate different sizes and shapes. Jason designed and patented a new binding that allows images to lie fairly flat. While plastic sleeves are often used, they are not necessary. Using Jason's metallic hinges, a photographer can be guaranteed a flat look.

If you find the type of book you are looking for at a pre-made company, check the workmanship. Make sure the book is sturdy and the quality of the book meets your standards. Lost Luggage is not the only company that meets special requests. There are other pre-made book companies that will often accommodate your needs without the expense of going to a book builder. Check the reference section at the back of this book for a listing of pre-made book suppliers.

If you have decided to have a special book and box designed and built exclusively for you, be prepared to pay a bit more. The results are well worth the price. I have worked with many book builders throughout the years and quickly came to realize the valuability of these creative professionals. For the last few years, I have worked exclusively with Angela Scott of Washington, D.C., and Nicole Anderson, who is based in California. I have developed a process for our working relationship, one that I suggest you use (see Appendix). The process is explained on page 110.

BELOW AND OPPOSITE PAGE While there are other companies that make pre-made portfolios, Lost Luggage, owned by Jason and Nina Brown, has quickly become an industry favorite. Special requests are filled regularly at Lost Luggage. Both Jason and Nina are graphic designers and they have created a product line that is tastefully beautiful and functionally perfect. The binding is a special system that Jason has created and trademarked.

BELOW, LEFT The classic Ice Nine portfolio from Lost Luggage looks beautiful and works well with contemporary images. © *LOST LUGGAGE*

BELOW, RIGHT The Ice Nine stitched Brown Leather is a version that suits work that is personal and warm. © *LOST LUGGAGE*

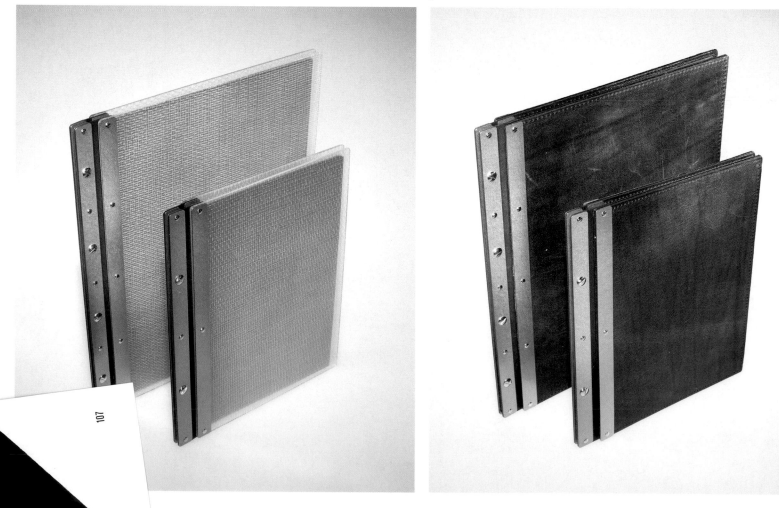

TOP An Ice Nine portfolio with a slip case to match. © *LOST LUGGAGE*

BOTTOM The Isotope binder system holds loose prints and boards. © *LOST LUGGAGE*

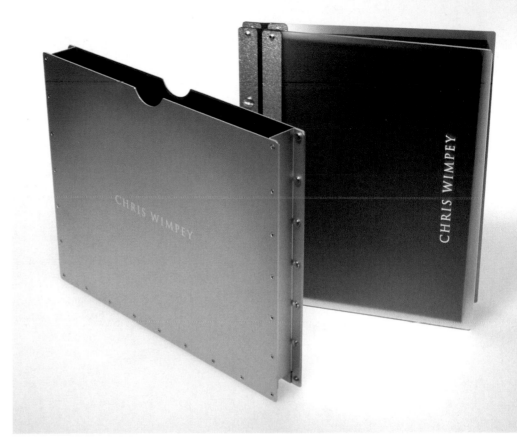

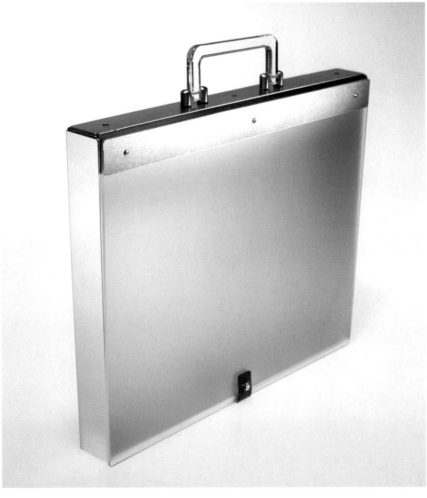

working with a PROFESSIONAL BOOK BUILDER

Always ask a builder how she works. She should give you an idea of the styles of books available, color swatches for the covers, and advice on shapes for your book, name placement, and other options, such as the use of book tape, a time-consuming process. Ask the builder if she will design your book in addition to the workmanship.

Always get references. Ask for the names of photographers they have worked with recently and less recently (2-3 years earlier). Call the most recent photographers and ask about the workmanship, whether the job was completed on schedule, and about the ease of communication. Ask those who had books created a while back if their books have held up. All books suffer from wear and tear, however, some are made better than others.

ASK THE BOOK BUILDER HOW LONG HER TURNAROUND TIME IS, AND ABOUT HER CURRENT SCHEDULE. WHEN YOU HAVE DECIDED ON A BOOK BUILDER BE PREPARED TO OFFER THE FOLLOWING INFORMATION:

– The size of your book

– Your preference in covers

– The color and shape of your book (horizontal, vertical, accordion)

– The type of paper you will be printing on

– The number of final pages

– The number of copies of the book or box that you will need

– An idea of where you would like a pocket to be (for leave behinds and your business card)

– Whether or not plastic sleeves will be used

– Your budget

As many book builders are artists in their own right and draw inspiration from your visuals; I feel it is important for them to see the work the book will house. Send your builder (5-7) sample images of your work. Once they have received the prints you will both be able to discuss the feel of the portfolio, the colors, and the details pertinent to creating a portfolio where the outside truly speaks to the inside!

A variety of cover materials, including book cloths and leather. Book cloth is backed with paper or sized specifically for bookbinding.

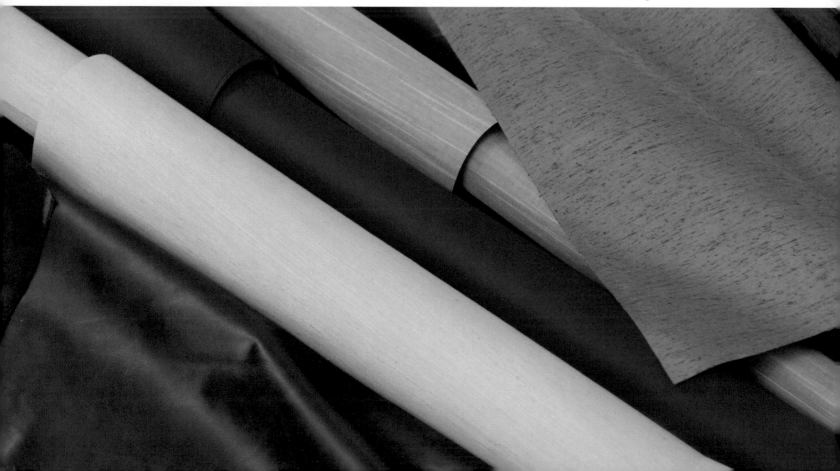

Bookmaker Nicole Anderson placing cover paper onto a portfolio. She creates handmade books for her clients, which include photographers, graphic designers, illustrators, and architects.

CD portfolios and web sites are effective marketing tools but have not replaced traditional portfolios. While some clients buy from web sites, most still call in print portfolios. Viewing web sites is a convenient way to browse for photography, and if the buyer sees something he likes, he will request the portfolio. Thus, a big mistake that photographers make is to invest heavily in a web site at the expense of a print portfolio.

Remember that most of your contacts need to sell you to someone else. Once an art buyer receives your portfolio, he has to sell you to an art director. A photo editor might report to an art director or confer with a feature editor. A marketing director may need the approval of the VP of corporate communications. Almost all of them report that they expect to use a print portfolio as their final decision-making tool.

CD portfolios can be used as a marketing tool, but they do not replace the print portfolio. Art buyers, like other people, get tired of working on their computer. Remember, thinking like a buyer is key to the success of your business. With that in mind, watch the trends. If in the future clients buy more from the web, make sure to comply.

trowel à la mode

Tearsheets

WHEN MAN RISES ABOVE THE SENSE OF DUTY, THEN DUTY BECOMES HIS PLEASURE.

–HAZRAT INAYAT KHAN, SUFI TEACHER (1882–1927)

Tearsheets are actual printed samples of work you have done for clients. They are well received, however not all photographers care to show them. You should consider showing tearsheets, because they build trust and provide you with extra credibility.

Many photographers choose not to use their tears if they consider them not to be well designed or printed. Others note that viewers often comment on the design rather than focus on the photography of the printed piece. While both of these negative aspects are true, they should not stop you from using appropriate tearsheets.

OPPOSITE PAGE Earl Kendall created this full-page bleed for a national retailer, Target. Including it in his portfolio builds his credibility with art buyers. *© EARL KENDALL*

BELOW From Earl Kendall's tearsheet book, theUnited Airlines ad shown as a two-page spread contributes to the perception that Earl is a photographer who can be trusted for national campaigns. He also uses this spread as a sourcebook ad. *© EARL KENDALL*

Tearsheets provide extra information that in some cases has won a job for a photographer. They show a client that you have worked, whom you have worked for, and how you handled the assignment. In situations where your contact is not the final decision-maker, a tearsheet book helps your contact sell you to their client.

It is acceptable to scan in your tearsheets to get a clean output. With this technology, you can take pieces of an annual report, combine them with the corporate logo, and produce a tearsheet that shows off your work beautifully. You can take newspaper articles, magazine articles, and covers of brochures, and produce better samples than the originals.

You can now include projects in which you were one of many photographers hired, or pieces that include stock and assignment work, choosing only those sections that show your visual contribution. Considering the value of tearsheets to your clients, and the ease of including them, there is no reason not to have a tearsheet section as part of your portfolio.

The simplicity, lighting style, and minimal propping make this ad for Cross pens classic Earl Kendall. © *EARL KENDALL*

tear section or TEAR BOOK?

You can make this decision by the number of tearsheets you are using. Do not mix tearsheets into your gallery book. If there are only a few, you may choose to house them in a separate section in the back of your portfolio. You should use a post-and-bound book, so that your images stay where you want them. If you find that you have many tearsheets, you will want to create a separate book. It can also include a biography, articles, and a client list.

As you look through your tears for possible choices remember that tears are not the same as the gallery section of your portfolio.

Their purpose is to build credibility, to give prospects an understanding as to which clients you have worked with and how you solved their creative needs. The criteria for including tears is whether they add to your credibility and build a client's trust in your abilities. Don't include tearsheets that show their age or are poorly designed.

If it looks like any of the tearsheets you want to keep need retouching, you can scan them and print them out.

housing for your TEARSHEET BOOK

A difference in size between your gallery book and the tearsheet book will help contacts to distinguish them. Most photographers use an 8x10" tearsheet book. If you show originals, consider using plastic sleeves in order to create spreads. While I am not at all a fan of plastic sleeves for use in a gallery book, they are an option for your tear book. The plastic protects the pages, and allows you to create spreads easily.

When formatting tearsheets, another option is to scan in the originals and reprint them on a medium-weight paper. This allows for consistency and a cleaner look.

Once you have determined the size, and the presentation styles, begin to think of how you will coordinate the outside of your tear book with the gallery book. If you have purchased a pre-made book, go to your supplier to see if they have smaller version of your gallery book, or look to coordinate colors. Play a bit.

If you have been working with a book builder, you most likely would have talked to them at the outset about what the tear and gallery books will look like.

Remember that when tear books are used alongside a gallery book, a box to house them both is suggested.

RIGHT When creating your tearsheet book, match its cover to your gallery book or box. Michael Indresano created a very effective tearsheet book that is simply covered with black leather that matches his portfolio box. The Indresano logo is front and center. © *MICHAEL INDRESANO*

BELOW I detest plastic sleeves in a gallery book, but in a tearsheet book, I welcome them. They protect the lighter pages and create a distinction from the gallery book. Note how Indresano has created spreads within the tearsheet book. Very impressive. © *MICHAEL INDRESANO*

other ways to BUILD CREDIBILITY

IF A TEARSHEET SECTION OR BOOK IS NOT FOR YOU, THERE ARE OTHER WAYS TO BUILD CREDIBILITY.

– A well-written autobiography can provide viewers with extra information about who you are and what you do.

– A printed client list can be inserted into the back of your portfolio. Usually, this includes the name of the company, publication, agency or design firm. But it can be handled a bit more creatively. For example, one photographer printed up a page of company logos representing her clients. Put the most recognizable names on the top, and don't go back farther than three years.

– A statement of your creative philosophy can complement your vision, giving potential clients insight into your inspiration and ideas.

BELOW AND FOLLOWING PAGE On Michael Grecco's web site, he shares his work philosophy. Here is the exact wording. As you can see, it provides a nice introduction to the images that follow.

Michael Grecco is a chameleon with an attitude. Olympic athletes, movie stars, divas, CEOs, factory workers, politicians—he has photographed them all, and the images he has created have graced the covers of the nation's top magazines and national ad campaigns.

His goal has always been to produce images that will make a viewer stop. Grecco has one image in which to convey a lot of information. His subject is his inspiration. Beginning with a concept that often involves humor and irony, he develops a lighting style, one that has often been described as atmospheric and unconventional. And then he's off—putting Johnny Depp on a pool table, a boy in a bathtub covered in shaving cream, or the CEO of Southwest Airlines, Herb Kelleher, inside a jet engine.
© *MICHAEL GRECCO*

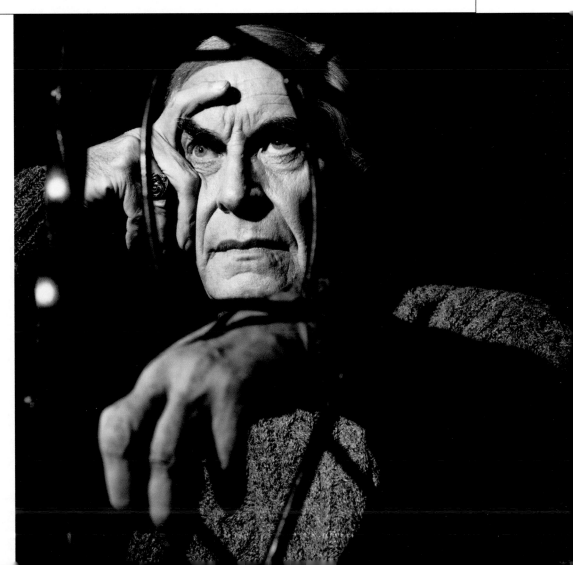

Martin Landau: dark, dramatic, and riveting. © *MICHAEL GRECCO*

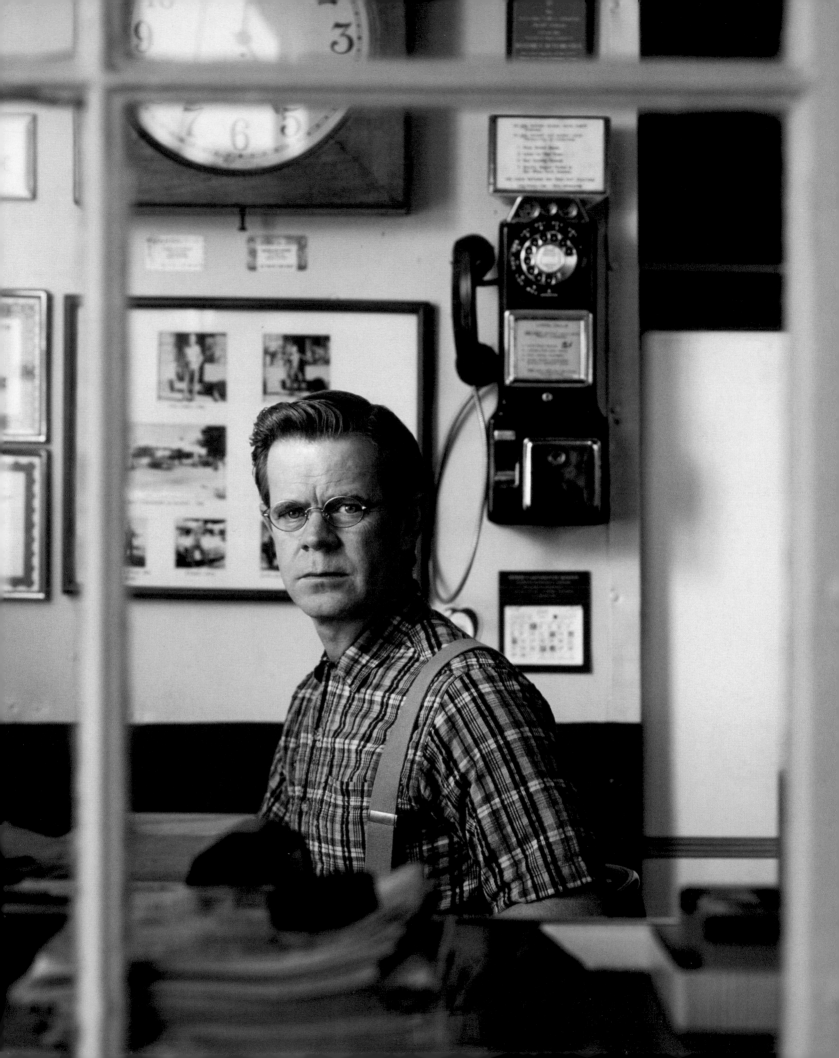

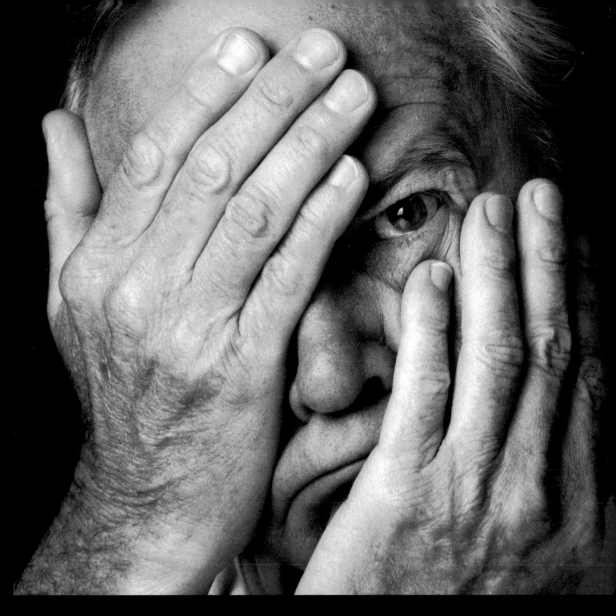

RIGHT This unusual and serious photo of Jack Lemmon speaks to the person, not the persona.
© *MICHAEL GRECCO*

OPPOSITE PAGE William Macy à la Grecco, taken as an ad and PR shot for USA Network.
© *MICHAEL GRECCO*

FAQs ON CLIENT LISTS

1. Should the client list be in alphabetical order?

 No. Similar to a resume, a client list is rarely read from top to bottom. Pick the most recognizable names and put them at the top. Also, consider your target audience. For example, if you are going for food accounts, move your food clients to the top of the list.

2. Should I list the company or the person?

 Always list the company. Most people will not recognize the name of your individual contact.

3. What if the company is unknown? Should I still keep it on the list?

 Absolutely. The fact that you have clients is what is important!

4. How many shoots do I have to do for a client before I can put it on my list?

 One.

5. How old a client is too old to list?

 I recommend that photographers go back as far as 3 years.

Using Your Portfolio as a Marketing and Sales Tool

ALL THAT IS DONE AND CANNOT BE HELPED, I LEAVE TO FATE; BUT I FEEL MYSELF RESPONSIBLE FOR ALL THAT IS TO BE DONE.

–HAZRAT INAYAT KHAN, SUFI TEACHER (1882–1927)

Now that your book is complete you need to develop your sales and marketing programs. To reiterate, your portfolio should function as a marketing tool; it should be sent out cold to prospective clients. Next, it should also be used as a sales tool, sent in response to a request, when the prospective client has an assignment in mind. With an integrated program, your book will get called in for assignments. At the hub of this program is your vision.

BELOW AND OPPOSITE PAGE Francois Gagné is based in Boston, Massachusetts. The two pages reproduced here represent his still-life portfolio, which is in the form of a spread book. Moody, evocative, and elegant, his images are viewed by art directors, art buyers, and editorial photo editors throughout the country via drops and in-person visits, which his agent, Inge Milde, takes care of. © *FRANCOIS GAGNÉ*

the portfolio as a MARKETING TOOL

At the marketing stage, your goal is to increase your client base. To do this, there are certain strategies to take, which include arranging in-person portfolio visits and appointments to drop off your portfolio. Many photographers don't make appointments, insisting that no one does in-person visits anymore. While getting appointments is difficult, many photographers and agents are doing this every day. The latter gives the prospective buyer a chance to view your work before there is a need. In your portfolio is a leave-behind, which he will keep for future reference.

Clients are very busy and often prefer to review portfolios that have been dropped off. It may feel too impersonal, but it is a method that is often favored, so get past your ego and organize a drop-off program.

Other marketing tools, such as direct mail, emails with imported images, and web sites, serve to reinforce your vision and repeatedly remind the viewer of your style and availability.

Begin by creating a list of clients you want to approach. Then drop off your portfolio. Include a leave-behind, such as a postcard, so that they can contact you in the future. When clients have projects to assign, they start to round up their best candidates. For agency contacts, it is not uncommon to pull in up to fifty portfolios for one project. Graphic design firms tend to pull in around twenty, and corporations pull in around fifteen.

Clients often welcome your sending or dropping off a portfolio, as long as you make an appointment to do so. Editorial publications, in particular, often have drop-off days. Call first to get their drop-off policy.

"I always make time to see drop portfolios," said Karen Frank , the photo editor at O magazine. "As long as the photographer calls ahead and is willing to leave it for a few days, the book definitely gets looked at."

preparing for a PERSONAL VISIT

It can be difficult to get an appointment for a personal visit, but keep trying. To make the most of your visit, research the contact beforehand. Find out as much as you can about their needs. For example, if it is an agency contact, find out what accounts they handle. If it is a corporate contact, learn about the company's products or services. For editorial publications, familiarize yourself with the magazine and understand who its audience is.

It's a good idea to arrive at the appointment early (never be late!) "Get to the appointment early and sit and watch," recommends Susan Austrian, a Minneapolis-based consultant. "Get the feel of the agency. Each company, agency, and design firm has its own culture. I like being able to sit for a bit and get the sense of the firm. Look at the walls for copies of the ads or design pieces the company produced."

Once you get an appointment, make the most of it by asking pertinent questions. Mention the account that you're interested in and ask your contact to show you examples of ads already produced for the client. As the appointment draws to a close, ask your contact what is the best way to keep in touch, mentioning direct mail and visual email as options. Ask if there are other contacts in the company or other companies that he feels you should see.

You may need to go on several visits to a single contact over an extended period of time before you land an assignment.

the portfolio as a SALES TOOL

CONGRATULATIONS! YOUR PORTFOLIO HAS BEEN CALLED IN. NOW GET TO WORK:

1. Ask your contact what account the book is up for.

2. Ask him to describe how the account assignment is currently being handled.

3. Ask if he wants to see any specific types of samples.

4. Send your portfolio, along with those specific samples. This is when a book builder can advise you on having a folder or mini-book made that matches your portfolio.

5. Send articles or press materials you feel are relevant.

6. Ask your contact when he expects to return your book and when a decision will be made.

7. Feel free to also ask him for a shipping agent account (such as FedEx or Airborne Express). The client requested your book, so he will expect to pay for delivery of it both ways. Make it easy for him by including a completed return airbill.

The hardest part is waiting. Wait two days beyond the return date you were given and call to check on your portfolio's whereabouts and an update on the assignment pending.

BRANDING YOUR WORK

Your overall plan must integrate your vision with who you are and what you have to offer. Your work becomes a brand. When art buyers want a particular feel or look, they think immediately of you. Let your portfolio be the hub for all your branding efforts. Branding your portfolio and other marketing tools will enable viewers to remember your visuals and understand your visual value more quickly.

"When you're trying to win a prospective client, always remember that your book is only part of the presentation. I believe that clients also want to get a feel for what it's like to work with you," said Mike Howell, a Boston-based copywriter, who has worked with many photographers on their promotional campaigns. "They want to get a sense of what kind of person you are, what spending a day (or a week) shooting with you is like."

That's why it's so important to implement a variety of marketing tools and strategies, in addition to the portfolio. You need to reinforce your vision. Your assignment, then, is to take the visual look of your portfolio (as well as the actual content) and use it in all your marketing material.

As your portfolio becomes the visual and content reference for all other tools, you are in essence branding your company. Branding is not only about the look of your marketing tools. It's also about the messages that they convey. What better message to start with than your vision? It is you, it is powerful; it is what clients will be buying.

Simon Plant shows his versatility within the same vision—from shooting a basketball player caught in action to the serenity of this harbor scene © *SIMON PLANT*

DIRECT MAIL

It's a good idea to send one piece of mail per month for six months after you have sent in your portfolio. After that, you can reduce it to one every other month. These mailers are a piece of your vision, serving to remind the contact of your work. The consistency is especially important for newer talents, who are looking to build name and visual identity.

"Every now and then, send me a postcard 'from the edge.'" advises Rich Hollant, an award-winning graphic designer. "A postcard you say? Yup, a postcard. If you have been pouring your soul into your work it'll show. Once a month, send a 6 x 9" card."

Postcards are great for photographers, on a tight budget, who want to reach clients. On the card, be sure to direct viewers to your web site, where they can look at more of your work and contact you.

A direct-mail campaign can include any kind of printed pieces designed specifically to remind the viewer of your vision, not just postcards. If you're using postcards, Modern Postcards is a full-service supplier, from producing to mailing them out, a service that is very popular with photographers (see Appendix A).

BELOW Zave Smith sent cards to buyers every month for five months. The visuals came from the portfolio and were printed on a paper stock with rounded corners. The cards were sent in brightly colored vellum envelopes to pick up on the purple color of Zave's new vision-based portfolio. Zave's contact information was on the back of the card, allowing for full visual impact on the front. © *ZAVE SMITH*

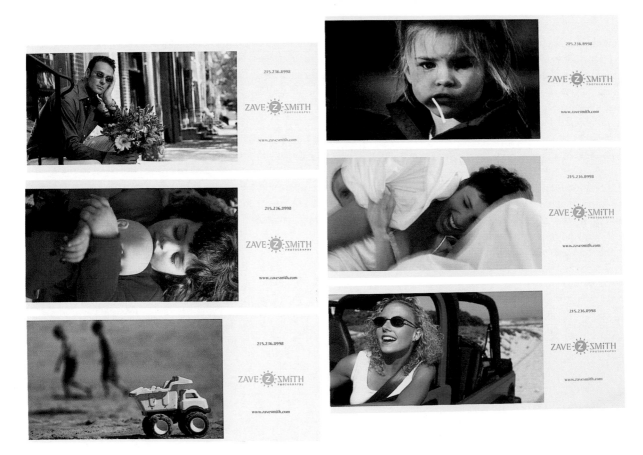

OPPOSITE PAGE, TOP Michael Indresano used these mailers for regional and national prospects. Transparent envelopes made of vellum, enticed viewers to uncover the images within. The images were carefully chosen from Michael's portfolio as they represented the type of accounts that he was interested in. © *MICHAEL INDRESANO*

OPPOSITE PAGE, BOTTOM Sent in a silver envelope, these pieces had a cover shot with Michael's very distinctive logo, two inside shots and corporate identity on the back page. The mailer format mirrors Michael's portfolio, source book pages, and web site design. This allows for continuity of vision, and builds name recognition for Michael. © *MICHAEL INDRESANO*

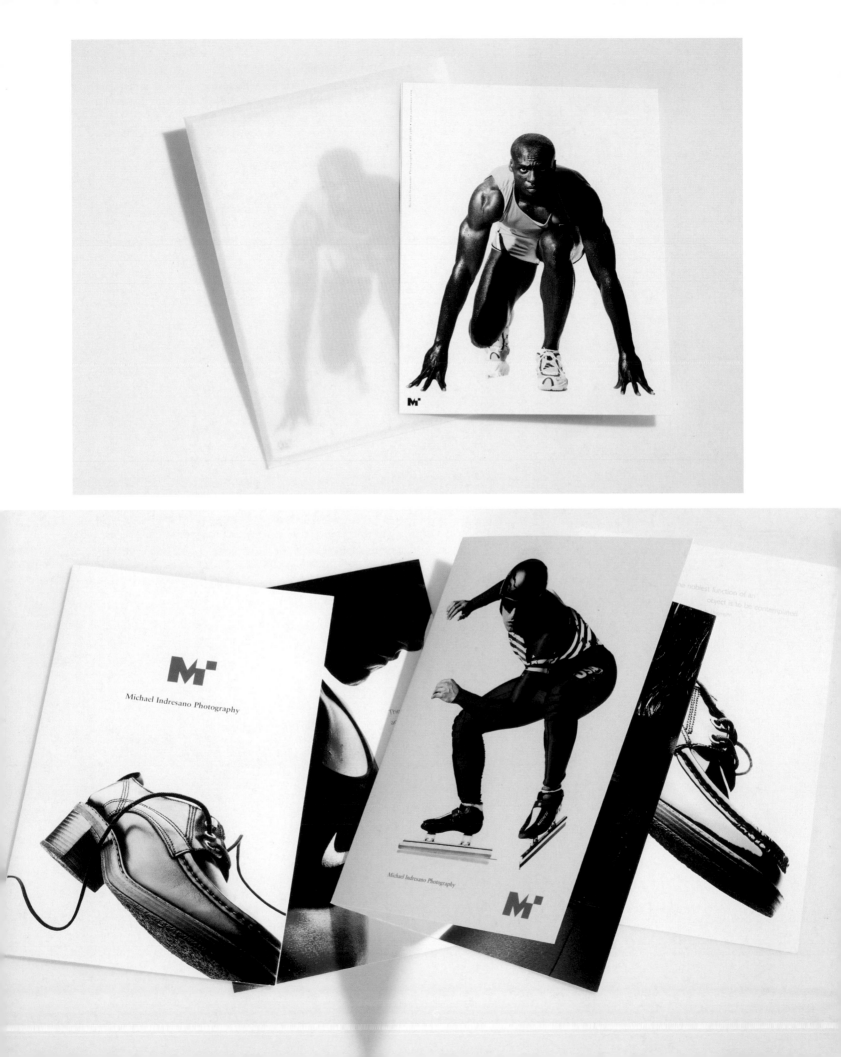

LEFT When Michael opened his digital facility at a separate location, it was important to let clients and prospects know that there indeed would be a consistency of vision and service. With that goal in mind, direct mail was designed to reflect previous Indresano mailers but speak to the needs of the digital client. This explains the copy: Contour, Output, and Details. The copy reinforced the message.
© MICHAEL INDRESANO

BELOW Working with a designer and copywriter, Patrick developed a concept that shows his sense of humor and his understanding of a buyer's business environment. Each page of "Meeting Notes" had a funny anecdote about the business world. The tagline he uses on his web site, emails, and corporate identity—"I love to work"—ties in beautifully with these promotional pieces. © PATRICK PROTHE

ABOVE Patrick Prothe developed a campaign that aimed to communicate his vision, as well as who Patrick was as a person and what his company stood for. The visual mailers shown were images taken directly from the portfolio, and the "Meeting Notes" and working pad were sent as a followup to in-person portfolio visits. © *PATRICK PROTHE*

EMAIL

Some buyers don't like unsolicited mail, electronic or otherwise. Here's my take: Do it! My experience has been that the overwhelming majority of buyers do not object to direct mail or email. It is often said that as we get older, buyers get younger. More and more buyers are relying on the Internet daily. They chat, buy products and services on line, do research, and exchange ideas continually via the web. So don't be afraid of it. In response to emails, many photographers receive requests for their book and have seen the traffic on their web sites increase dramatically. Most importantly, assignments result from emails.

Having said that, there are some guidelines to follow. An email to cold contacts should be kept brief, basically letting them know the type of work you do and asking them to check out your web site.

If they are not interested in receiving emails in the future, give contacts a way to opt out, and make sure they are removed from your list.

A visual email is similar, but it includes an image built into the body that contacts can immediately view upon opening the mail. Never send an attachment, as people are wary of receiving viruses. Instead, embed the image in the email. Check state laws, as some states ban global emails, deeming them to be spam.

It is your job to let prospects know that you are there. The phone is no longer an effective marketing tool (it's okay for making appointments). Send approximately 700–1000 emails and see how many come back.

WEB SITES

A web site is a critical component in your program. Most buyers use web sites as initial sources for viewing talent when looking to hire. Your web site should include several sections. First, there should be a portfolio section that matches your physical portfolio.

Then there should be pages where contacts can see tear sheets, a client list, and/or your biography. Consider a section devoted to recent test shots. Every page on your site should provide your contact with the opportunity to immediately email you and the entire site must be visually branded with your portfolio, direct mail and source book pages. Your site should be linked with two to three host sites that your target market visits regularly when looking for talent. *Black Book, WORKBOOK, APA* and *ASMP* are all current web directories that clients use. There are directories with new ones popping up monthly. Ask your contacts which online directories they frequent before you pay for any service.

A web site is a good place to display additional images that are not appropriate to include in the gallery section of your portfolio. You need to look at any new photos and see if they suggest your current direction. If they do, make sure they give your viewers a message consistent with your vision. If they pass the test put them on your site.

If the images are completely off message, resist the urge to put them on your site. Put them on your wall instead. As you continue shooting, if you begin to develop a body of work that you feel is significant, marketable, and will not confuse your direction, then look to create a new portfolio based around the work.

SOURCEBOOKS

Sourcebooks are published and distributed yearly to buyers. The major books, *Black Book, WORKBOOK, KLIK,* and *Alternative Pick* house the work of photographers who have paid a premium fee to have a page or a spread of their work represented in the book. There are other regional sourcebooks that contain the work of photographers in specific geographic areas.

Photographers often think that marketing is all about sourcebooks. I believe that a photographer must develop a vision-based portfolio and an active, consistent, direct mail program and web site *before* considering a sourcebook. It's best to start by building your identity.

"Remember, a source book, although usually released once a year, has a long shelf-life. It is not uncommon to receive a call based on an ad run 3–5 years prior. My advice? Have as many sourcebook ads as you can afford," said Jean Burnstine, national sales director for *Black Book*. Consistency is key. Plan to advertise at least three years in a row in the same book. Do not jump books year to year and expect results.

When considering which book to buy into, don't let the price be the determining factor. Consider who uses the book and make sure that they are your key contacts. Jean reminds us that "source books are designed to bring in the calls. Getting the job is up to you, your portfolio, and your bid." A sourcebook ad with no portfolio to back it up will surely backfire.

These spreads by Michael Indresano appeared for three years in a row in *Black Book*. Note that while the images changed, the format of the page remained consistent. The clean layout follows the look of Michael's portfolio, direct mail and web site. The consistency of design year after year allows clients to easily recognize and remember Michael's work.

BELOW The photo of Nomar Garciaparra (the Boston Red Sox Star) was photographed for *Sport* magazine. The publication printed a different version. Michael liked this shot as it focused on Nomar's spirituality. The companion image is a test that was shot for the portfolio. The idea was to directly appeal to sports manufacturers.

© MICHAEL INDRESANO

Nomar Garciaparra

Michael Indresano Photography
617.269.2400

Angie Graham

LEFT Keith Lockhart, the conductor for The Boston Symphony Orchestra, is paired with comedian Jay Leno.
© *MICHAEL INDRESANO*

BELOW Lawyer Malloy of The New England Patriots is intimidating on the field and this photo portrays the edge he brings to his game. The juxtaposition of Malloy's portrait and a rear view of Nomar Garciaparra created a nice contrast. © *MICHAEL INDRESANO*

building a SECOND PORTFOLIO

At this point, building a follow-up or second portfolio is probably the last thing you want to think about! So I'll make it brief. Consider building a new portfolio about 4–6 months after you have completed your first book. You need to make sure that your second book is ready to rock a year after the first started.

You're not retiring the first portfolio. A second portfolio targets existing and new contacts.

If you are a still-life shooter like Patrick Prothe, and you are interested in photographing people, then start to experiment and set up shots and see where your eye leads you. If you are a corporate location shooter and your first portfolio contains people, architecture, and product coming off the line, consider creating a second book that takes one of these areas and explores it further. The idea is to create a portfolio that can be shown to both contacts that have seen your first book and also to new contacts. Your second book should be a natural extension of your first; it should not be a book in a completely different direction!

I often suggest that photographers create mini-portfolios as second books. These are books that have fewer images in them, around 7–10 each. The images are based on a subject or theme, or can be an extension of a subject in the last portfolio. You can also use a mini-portfolio as a drop book, as long as it reflects the same quality and commitment as your primary portfolio.

Successful marketing programs never stop. Just as your mailers need to change, so will your portfolio. It's all about vision, and growth. If you are continuing to work your eye, your talent, the examples of that talent will begin to shift. This is natural; this is good. Your job is to make sure that current books reflect your vision today!

BELOW AND RIGHT Joe Lee's portfolio of family moments will soon be complemented by his second book, which he is currently working on. It is critical that you begin your second book after your first is completed. The boy with ticket and the mother and son are client favorites and the new book will contain more adults and continue the theme of family moments. © JOE LEE

A PHOTOGRAPHER NEEDS THE FOLLOWING TO CREATE A SUCCESSFUL MARKETING PROGRAM:

- **CONTACT LIST:** Refine your list to include clients who have the type of assignments you are seeking. Remember to cross-market.

- **DROP PORTFOLIOS:** This is important to busy clients who don't have time for in-person visits.

- **APPOINTMENT CALENDAR:** Don't rely on memory to keep track of your shooting schedule and your drop-off program

- **RESPONSE SHEETS:** These give you feedback and help you keep track of who is interested. (Samples are provided in Appendix.) Be aware that only a small percentage of contacts will respond. It's still worth the effort, as those who fill out the sheets will be key contacts.

- **LEAVE-BEHINDS:** These include reprints of sourcebook ads, postcards, and other appropriate printed samples of your work. Art buyers can refer to them when assigning work.

COMMITMENT

I have often told clients and photographers attending my presentations that the information that I share will mean nothing without the commitment of the photographer to change. The book that you have just read was written to help you to create a vision-based portfolio that will sell.

But it will be up to you to work the process and commit to success. While building your portfolio, there will be times when you will be as giddy as a teenager. There may be times when you will be depressed, stuck, and just ready to throw your hands in the air. You will experience different levels of interest and energy along the way. However, your commitment to building a portfolio that sells must never waver. It will be your commitment that will sustain you during your most difficult times and keep you on track as the realities of daily life seek to distract your attention from your process.

Twenty years ago, Kevin Prieur shared these powerful thoughts with me. I share them now with you:

"Until one is committed, there is hesitancy, the chance to draw back. Concerning all acts of creation, there is one elementary truth: providence aids those who are committed. A stream of events flows from making this conscious decision. As Goethe said, 'Whatever you can do or dream, you can begin it. Boldness has genius, power, and magic in it.'"

RIGHT AND OPPOSITE PAGE Always in search of new ways to express his personal vision through photography, Steven Begleiter has spent the last five years experimenting with color infrared film. This has led to a completely new body of commercial work that has been described as "simultaneously electric and subtle."
© *STEVEN BEGLEITER*

BELOW AND OPPOSITE PAGE Simon Griffiths' portfolio contains lifestyle illustrations that are evocative and often include a sense of whimsy and humor. His logo and a consistent color palette are on every tool he uses, from letterhead to mailers to portfolio. The "Simon" logo is as distinct as the photography he creates.
© *SIMON GRIFFITHS*

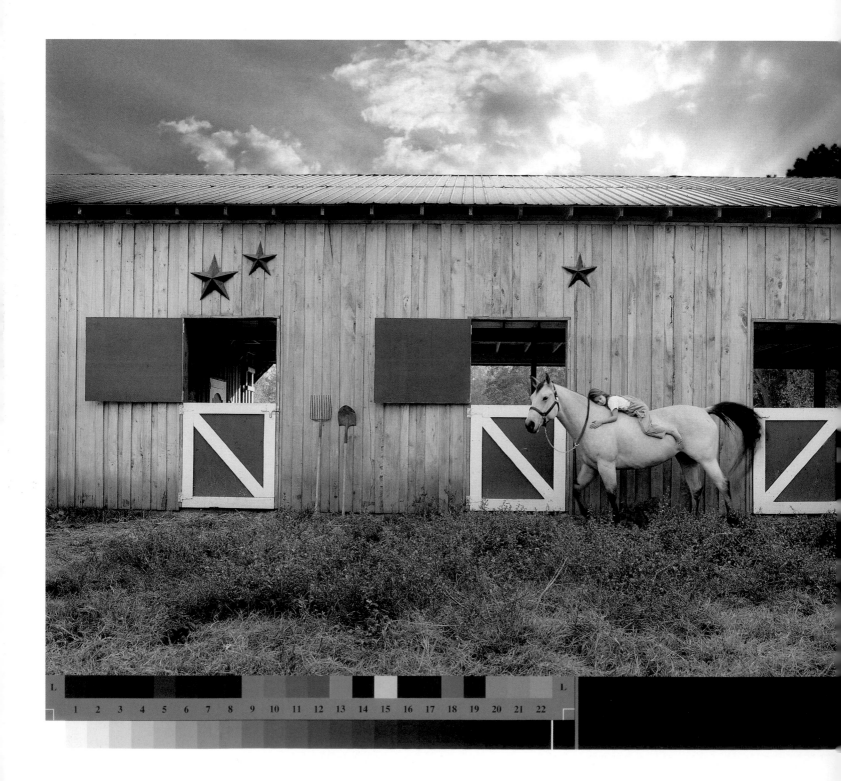

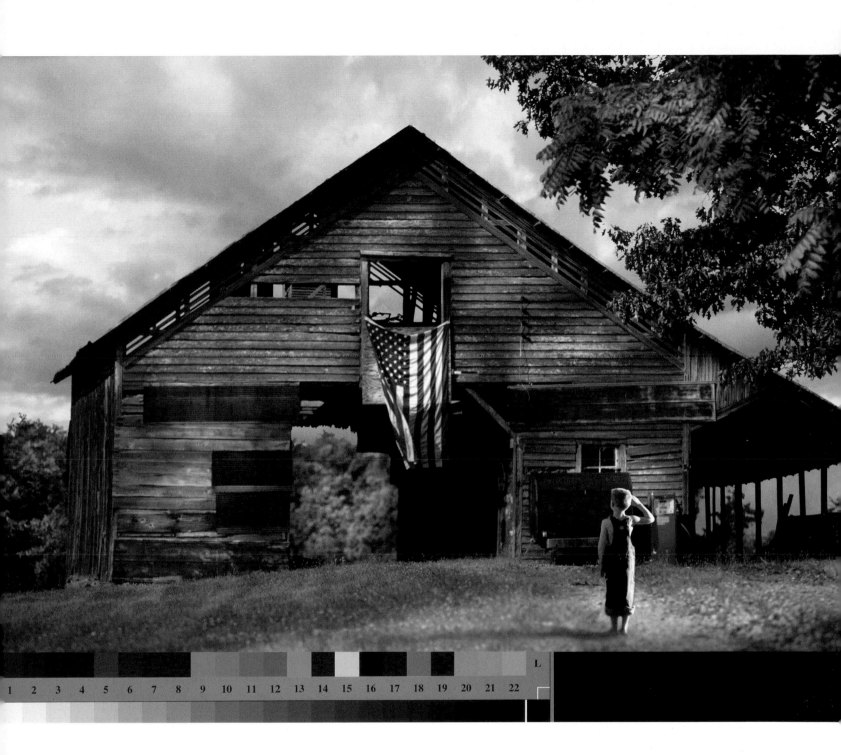

PORTFOLIO BOOK BUILDERS

ADVERTISER'S DISPLAY BINDER CO. INC.
50 Dey Street #5
Jersey City, NJ 07306

P: 800-489-3246
P: 201-795-3515
F: 201-795-9280
E: adb@nac.net

http://www.adbportfolios.com

BREWER-CANTELMO CO.
350 Seventh Ave.
New York, NY 10001

P: 212-244-4600
F: 212-244-1640
E: info@brewer-cantelmo.com

http://www.brewer-cantelmo.com

LOST LUGGAGE
1733 Westlake Ave. North
Seattle, WA 98109

P: 888-567-8456
F: 206-441-7196
E: info@lost-luggage.com

http://www.lost-luggage.com

PINA ZANGARO
2200 Jerrold Avenue
Unit L.
San Francisco, CA 94124

P: 415-206-9582
F: 415-206-0492
E: info@pinazangaro.com

http://www.pinazangaro.com

PORTFOLIOBOX, INC.
166 Valley Street, Bldg. 3-402
Providence, RI 02909

P: 401-272-9490
F: 401-454-8167
E: info@portfoliobox.com

http://www.portfoliobox.com

PRAT
4340 Almaden Expressway, #210
San Jose, CA 95118

P: 800-900-4720
P: 408-264-5761
F: 408-264-5760
E: infos@prat.com

http://www.prat.com

TALAS
568 Broadway, Ste. 107
New York, NY 10012

P: 212-219-0770
F: 212-219-0735
E: info@talasoline.com

http://www.talasonline.com

THE HOUSE OF PORTFOLIOS CO., INC.
52 West 21st Street
New York, NY 10010

P: 212-206-7323
F: 212-633-2247
E: info@houseofportfolios.com

http://www.houseofportfolios.com

HANDMADE PORTFOLIOS

NICOLE ANDERSON BOOK ARTS
555 O'Neill Avenue, No. 1
Belmont, CA 94002

P: 650-596-0775
E: nicole@nabookarts.com

http://www.nabookarts.com

JOANNE KLUBA, BOOK ARTIST
Paper Birds
7909 Menola St.
St. Louis, MO 63123

P: 314-752-2551
E: joanne@paperbirds.com

http://www.paperbirds.com

ANGELA SCOTT, BOOK BUILDER
740 7th St. SE
Washington, DC 20003

P: 202-547-7945
E. AngelaScott1953@aol.com
http://www.angelascottstudio.com

ART Z
Division of Olson Design Company, Inc.
PO Box 6568
Bozeman, MT 59771

P: 800-789-6503
P: 406-586-8720
F: 406-586-8732
E: info@artzproducts.com

http://www.artzproducts.com

SHIPPING CASES

LIGHT IMPRESSIONS
PO Box 22708
Rochester, NY 14692

P: 800-828-6216
P: 585-271-8960
F: 800-828-5539
E: liwebsite@limpressions.com

http://www.lightimpressionsdirect.com

TENBA QUALITY CASES, LTD.
50 Washington Street, 8th Floor
Brooklyn, NY 11201

P: 718-222-9870
F: 718-222-9871
E: tenba@tenba.com

http://www.tenba.com

MAILING LIST SUPPLIERS

ADBASE INC.
298 Markham Street, Ste. 5
Toronto, Ontario M6J 2G6

P: 877-500-0057

F: 877-500-0067
E: sales@adbase.com

http://www.adbase.com

CREATIVE ACCESS (NATIONAL SERVICES)
415 W. Superior Street
Chicago, IL 60610
P: 800-422-2377
P: 312-440-1140
F: 312-440-1110
E: response@creativeaccess.com

http://www.creativeaccess.com

STEVEN LANGERMAN LISTS
36 Mussey Road
Scarborough, ME 04074

P: 207-396-5674
F: 207-396-5305
E: info@langermanlists.com

http://www.langermanlists.com

THE WORKBOOK
10 E. Ontario
Chicago, IL 60611

P: 800-752-0285
P: 312-944-9925
E: info@workbook.com

http://www.workbook.com

DIRECT MAIL SERVICES

MODERN POSTCARD
1675 Faraday Ave.
Carlsbad, CA 92008

P: 800-959-8365

http://www.modernpostcard.com

MARKETING SUPPORT SERVICES

SUSAN AUSTRIAN
Austrian Photo Marketing
12605 Hilloway Road
Minnetonka, MN 55305

P: 612-325-4429
F: 952-544-4327
E: saustrian@mn.rr.com

MINNESOTA CREATIVE SOURCEBOOK, INC.
5301 Thotland Road
Golden Valley, MN 55422

P: 763-509-9300
F: 763-509-0874
E: sales@mncreative.com

http://www.minnesotacreative.com

THE BLACK BOOK
10 Astor Place, 6th Floor
New York, NY 10003

P: 800-841-1246
P: 212-979-6700
F: 212-673-4321
E: info@blackbook.com

http://www.blackbook.com

PAPER SUPPLIERS

**CACHET FINE ART
PHOTOGRAPHIC PAPERS**
1161 Martens River Cir. Ste. D
Fountain Valley, CA 92704

P: 888-322-2438
P: 714-432-7070 Ext. 617
F: 714-432-7102
E: cachet@fea.net

http://www.onecachet.com

EPSON AMERICA, INC.
3840 Kilroy Airport Way
Long Beach, CA 90806

P: 800-873-7766 (store)
P: 562-981-3840
F: 562-290-4401

http://www.epson.com

LEGION PAPER—WEST
6333 Chalet Dr.
Los Angeles, CA 90040

P: 800-727-3716
F: 562-927-6100
International Phone: 562-928-5600
E: info@legionpaper.com

http://www.legionpaper.com

LEGION PAPER—EAST
11 Madison Avenue
New York, NY 10014

P: 800-278-4478
F: 800-275-3380
International Phone: 212-683-6990
International Fax: 212-683-8996
E: info@legionpaper.com

http://www.legionpaper.com

ILFORD IMAGING USA, INC.
W. 70 Century Road
Paramus, NJ 07653

P: 201-265-6000
F: 201-265-0894
E: us-techsupport@ilford.com

http://www.ilford.com

MIRAGE INKJET TECHNOLOGY
230 East Alondra Blvd.
Gardena, CA 90248

P: 888-MIRAGE-6
F: 310-768-2882
E: info@mirageinkjet.com

http://www.mirageinkjet.com

DIGITAL ART SUPPLIES
4901 Morena Blvd. Ste. 1109
San Diego, CA 92117

P: 877-534-4278
F: 858-273-2576
E: info@digitalartsupplies.com

http://www.digitalartsupplies.com

LEXJET DIRECT
1435 South Osprey Ave.
Sarasota, FL 34239

P: 800-453-9538
P: 941-330-1210
F: 941-330-1220
E: info@lexjet.com

http://www.lexjet.com

CALUMET PHOTOGRAPHIC
E: custserv@calumetphoto.com

http://www.calumetphoto.com

WEBER-VALENTINE, INC.
1099 E. Morse Ave.
Elk Grove Village, IL 60007

P: 800-323-9642
P: 847-439-7111
F: 847-439-6887
E: webmaster@weber-valentine.com

http://www.weber-valentine.com

BERGGER PRODUCTS, INC.
5955 Palo Verde Dr.
Rockford, IL 61114

P: 815-282-9876
F: 815-282-2982
E: sales@bergger.com

http://www.bergger.com

THE PALLADIO CO., INC.
PO Box 400028
Cambridge, MA 02140

P: 800-628-9618
P: 617-547-8703
F: 617-547-6810
E: palladio@napc.com

http://www.palladiopaper.com

MIS ASSOCIATES, INC.
282 Kirksway Ct.
Lake Orion, MI 48362

P: 800-445-8296
P: 248-814-9398
F: 248-814-0629
E: info@inksupply.com

http://www.missupply.com

STONE EDITIONS
PO Box 2383
Saint Cloud, MN 56302

P: 888-640-0033
E: info@stoneeditions.com

http://www.stoneeditions.com

SCHLEICHER & SCHUELL, INC. (HAHNEMUHLE)
10 Optical Ave.
Keene, NH 03431

P: 603-352-3810
F: 603-357-3627
E: techserv@s-und-s.com

http://www.s-und-s.de

AGFA CORP. (HEADQUARTERS OFFICE)
100 Challenger Rd.
Ridgefield Park, NJ 07660

P: 201-440-2500
F: 201-342-4742

http://www.agfahome.com

PASCO
224 48th Street
Brooklyn, NY 11220

P: 718-833-9100
F: 718-833-9118
E: pasco2@aol.com

http://www.rolandhifi.com

FUJI PHOTO FILM USA, INC. (CORP. OFFICE)
555 Taxter Road
Elmsford, NY 10523

P: 800-378-3854
P: 914-789-8100

http://www.fujifilm.com

EASTMAN KODAK CO.
343 State Street
Rochester, NY 14650

P: 800-242-2424 (General Info)
P: 800-235-6325 (Digital)

http://www.kodak.com/go/professional

LUMINOS PHOTO CORP.
PO Box 158
Yonkers, NY 10705

P: 800-586-4667
P: 914-965-3900
F: 914-965-0367
E: luminos@att.net

http://www.luminos.com

PICTORICO USA, INC.
2201 Water Ridge Pkwy., Ste. 400
Charlotte, NC 28217

P: 888-879-8592
E: orders@pictorico.com

http://www.pictorico.com

ARMADILLO PHOTO SUPPLY
9777 W. Gulf Bank, Ste. 1500
Houston, TX 77095

P: 800-762-8088
P: 713-937-8442
F: 713-937-8717

http://www.armadillophoto.com

YUPO CORP. (SYNTHETIC PAPER)
P: 888-USE-YUPO
F: 757-312-9702
E: info@yupo.com

http://www.yupo.com

KONICA PHOTO IMAGING
725 Darlington Ave.
Mahwah, NJ 07430

P: 800-285-6422
P: 201-574-4000
F: 201-574-4010

http://www.konica.com

MARK ANDERSON

By carefully considering location, graphic design, and color, Mark Anderson doesn't simply photograph subjects, but captures "people in their element." His clients include American Express, AT&T, Texaco, Microsoft, *Forbes*, *Money*, and *Marie Claire*. Aside from being a full-time commercial photographer, Mark Anderson is also the president/CEO of the Advertising Photographers of America (Atlanta chapter).

www.mandersonphoto.com

JAKE ARMOUR

Jake Armour founded Armour Photography in 1988, after completing a two-year program at the New England School of Photography. His business has grown to a staff of four and operates out of a new 6,600-square-foot studio in downtown Minneapolis.

www.armourphoto.com

O'NEIL ARNOLD

O'Neil Arnold is a corporate and editorial shooter specializing in people. He earned a bachelor's degree in physics from Berea College and a master of arts degree in photojournalism from Ohio University's School of Visual Communication. O'Neil began his career as a photojournalist for a daily newspaper before moving into the corporate arena. His background in science continues to influence his approach to observation and shooting. Among his clients are BP Benelux, Chrysler Financial Corp, Lloyd's of London and RCA Digital Satellite, as well as regional and national magazines.

www.oaphoto.com

MARK BECKELMAN

Mark Beckelman is an award-winning photographer with editorial, corporate, and advertising clients, including *Business Week*, Novell, and JVC. A graduate of Rochester Institute of Technology, Mark uses a surreal graphic style to effectively communicate ideas and concepts. He has been a photographer for 22 years.

www.beckelman.com

STEVEN H. BEGLEITER

Steven H. Begleiter is a professional photographer whose images have appeared in over a hundred publications, including *Time*, *Esquire*, and *People*. His commercial clients include *Reader's Digest*, Aramark, and Crunch Fitness, NYC. He lectures on photography at the University of Pennsylvania, and is the author/photographer of two books: *Fathers and Sons* (Abbeville Press, 1989) and *The Art of Color Infrared Photography* (Amherst Media, 2001). His third book *The Portrait* will be out in the Fall of 2003.

www.begleiter.com

SUSAN BOURGOIN/VISUAL CUISINES

Susan Bourgoin is a graduate of the Culinary Institute of America and attended the Southeast Center for Photographic Studies. She worked as a professional chef and food stylist before opening the Visual Cuisines studio in 1995. Susan has combined her knowledge and passion to create a company solely dedicated to the art of food photography.

www.visualcuisines.com

GEORGE CASWELL

In 1973, George Caswell was chosen to help develop a photography department at the Minnesota Museum of Art, which included the building of an industrial-size darkroom, photographing the museum's permanent collection, teaching photography, and more. He opened Caswell Photography in 1979. Later, he had the foresight to incorporate Adobe Photoshop, Corel Painter, Quark Xpress, and other programs into his visual repertoire.

www.caswellphoto.com

RENEE COMET

Renee Comet is a commercial photographer who specializes in food and still-life photography. In addition to her advertising clients, Renee has photographed over 30 cookbooks, including, *The Artful Pie, Joy of Cooking, Williams Sonoma Indoor Grilling,* and *The Mrs. Fields Cookie Cookbook*.

www.cometphoto.com

ELIOT CROWLEY

Eliot Crowley went to New York City after earning a Bachelor of Arts from Brooks Institute in Santa Barbara, California. After assisting many New York photographers, Eliot returned to California and opened his own studio. Shooting for the fashion industry, he was one of the first photographers in the downtown Los Angeles loft scene in 1979, and his studio was affectionately known as the Rainbow Room because of the vast amount of natural light. Eliot works for national advertising agencies.

www.eliotcrowley.com

FRANCOIS GAGNE

After moving from a small town outside of Quebec City to Portland, Maine, Francois Gagne set up his studio in a fantastic, old warehouse. He shoots both romantic and vivid still-life photographs for his clients, including Orvis, Brookstone, and Breck's Flowers. He has also done architectural work for hotels, art installations, and magazines. He lives with his wife Carole, and his beautiful daughters, Zoe and Eve.

www.imreps.com

MICHAEL GRECCO

Michael Grecco is known for pushing the limits of traditional portraiture with his edgy, offbeat style, making him one of the most sought-after portrait photographers today. His ability to create powerful visual statements has earned him international recognition. His critically acclaimed book, *The Art of Portrait Photography,* further illustrates his trademark sculpting of light and shadow.

www.greccophoto.com

SIMON GRIFFITHS

Born in London, England, Simon considers himself a native of North Carolina, where he has lived since 1971. He is the owner of Simon Studios & Gallery, based in a 70-year-old converted stone church building in the heart of downtown Raleigh. Simon's primary focus is photographing people for advertising, annual reports, and national editorial clients. He also produces humorous cards for AVANTI Press and is working on his own line of humorous Christmas cards.

www.simong.com

MARC HAUSER

Marc Hauser is celebrated internationally for his dramatic portraits. His varied list of clients includes *Rolling Stone* magazine, Pepsi Co., Ameritech, Arista Records, and Microsoft. Marc continues to explore and establish new boundaries in photography.

www.marchauser.com

TED HOROWITZ

Ted Horowitz is an award-winning photographer specializing in people and location photography for corporate and lifestyle work. His clients include Bristol Myers Squibb, Pfizer, Biogen, TKT, Citigroup, Paine Webber, Wyeth, J&J, Schering, IBM, ABB, Rockwell, AT&T, GE, Loral, Perkin Elmer, and hundreds of other Fortune 500 international companies. He has close to 30 years of experience photographing annual reports and similar projects.

http://www.horowitzphoto.com

MICHAEL INDRESANO

Michael Indresano creates high-impact visuals for international and national advertising, corporate, design, and editorial clients. An award-winning photographer based in Boston, Indresano has been the subject of numerous articles in national trade journals, and was named one of the top businessmen in Boston under the age of 40 by the *Boston Business Journal*. Indresano shoots in both analog and digital formats, with subjects ranging from world-class athletes such as Nomar Garciaparra of the Boston Red Sox to Buzz Aldren, the second man on the moon.

www.indresano.com

CAROL KAPLAN

For two decades, ad agencies and design studios have sought out Carol Kaplan for her unique and spontaneous photographs of children. Her clients include Little Me, Polaroid, Gerber, Stride Rite, Anheuser Busch, and Procter & Gamble, and agencies DDB Needham, Mullen, Arnold, and the Martin Agency. In recent years, Carol has brought to still life the same sensibility and sensitivity that characterizes her work with children.

www.carolkaplanphoto.com

EARL KENDALL

Earl works in Minneapolis, a major metropolitan market. He looks down from his 2nd floor studio with the power to enchant or disturb his enemies. Earl works on the north side of a street marked "South." For the moment, his passion overrides objectivity. Earl's lucky numbers are 38 23 6 10 14.

www.kendallphotographs.com

MARGARET LAMPERT

Fifteen years of experience has made Margaret Lampert one of the most well-reputed family and children's photographers on the East Coast. Her photographs offer very real glimpses into everyday life. Capturing simple, daily rituals like eating breakfast or playing Little League, her photographs speak volumes about people.

www.margaretlampert.com

JOE LEE

Joe has worked as a photographer on news and advertising assignments, which have taken him to Europe, many countries in Africa, South America, and the Caribbean, as well as throughout the United States. In addition to still-life photography, he has produced nine feature-length wildlife videos. Joe's clients include Federal Express, Sara Lee Corporation, Amoco, Weyerhaeuser, Bank One, Union Planters Bank, Morgan Keegan, Stanley Steemer International, Alcoa, AT&T, International Paper Company, Kroger, TGI Friday's, Con-Agra, Nikon, Coors Foods, National Geographic, Ingalls Shipyards, and even Elvis Presley.

www.joeleephotography.com

ROBERT KENT MELNYCHUK

Robert Kent Melnychuk, a professional photographer for nearly twenty years, is an international shooter with a strong interiors/exteriors foundation. He is known for his uncomplicated imagery, his current visual vocabulary speaks of people and products in spaces. His clients include Toyota, the Armani Exchange, Fairmont Hotels, and Host Marriott, and his work has appeared in *Architectural Digest, Metropolitan Home, House Beautiful,* and *Travel and Leisure,* among others.

www.robmelnychuk.com

JOHN MOWERS

John Mowers, lead photographic talent of Forté Studio in Minneapolis, has been contributing his work locally and nationally for the past 20 years. He recently won an award for his mailers, How magazine. He lends his vision to a variety of subjects including food, still life, and people. At Forté he combines his perspective with Russell Kerr, digital illustration artist.

www.fortestudio.com

MARC NORBERG

Marc Norberg is an artist who specializes in portraiture. His first book, *Black & White Blues* (Graphis), was a 12-year study of blues artists. He is currently producing two additional book projects, one concerning issues in mental health, and the other on the American landscape.

www.marcnorberg.com

SIMON PLANT

Simon Plant is a photographer based in England. He predominantly works for the advertising and stock photography markets, shooting images of life and location in his own unique style.

www.plantphoto.com

RICH POMERANTZ

Rich Pomerantz photographs gardens and people for editorial and corporate clients, including *Garden Design, Horticulture, Runner's World, Yankee, Connecticut Magazine, Travel Holiday,* and numerous textbook and calendar publishers, and UBS Warburg/Paine Weber, White Flower Farm, McDonald's, Unitec Manufacturing, and Holland America Cruise Lines. His stock photographs have been seen in *National Geographic for Kids, Coastal Living,* and the *Organic Gardening* and Sierra Club calendars.

www.richpomerantz.com.

PATRICK PROTHE

Patrick Prothe first picked up a camera when he was 10 and is largely self-taught. He studied advertising and magazine journalism at the University of Oregon, continually pouring over books on photography. Several years later, a two-week workshop with Jay Maisel at Andersen Ranch in Colorado transformed his vision. He now photographs people and products in and out of the studio for a wide variety of businesses and institutions from high-tech, to high-touch.

www.prothe.com

TED RICE

Ted Rice makes pictures of people for fun and profit. He specializes in making people who don't think they look good in pictures, look good in pictures.

www.tedrice.com/www.burnsautoparts.com

JOEL SHEAGREN

With 20 years experience, Minneapolis-based photographer Joel Sheagren shoots commercially for advertising. Published in *PDN, Applied Arts, Studio,* and *HOW* magazines for an award-winning self-promotion direct mail campaign, his photography received merit honors in ADCC/MN Ad Fed's 2002 The Show. National clients include FritoLay, Miracle Ear, Polaris ATV, Voyageur Outward Bound School, and Johnson Outdoor's *Leisure Life.*

http://www.ejoel.com

BILL SMITH

Bill Smith is an award-winning location photographer with more than 20 years experience doing commercial work. During this time, Bill has photographed for a variety of clients ranging from: national advertising agencies, design firms, and Fortune 500 corporations. In addition to his work as a photographer, Bill Smith has been a spokesperson for Kodak, American Express, Amphoto, Jamaica Tourist Bureau and now Mamiya America Corporation. His photographs have been showcased in many photo magazines, and numerous newspaper articles. He has appeared on CNN, UPI International radio, and featured in Kodak's Visions in View. Bill has also photographed and written three books: *The Caribbean* and the bestselling *Designing and Photograph.*

billsmithphotography.com

ZAVE SMITH

Zave Smith is a storyteller whose clients include AARP, BASF, Disney, Dupont, Lilly, Proctor & Gamble, and United Healthcare. His work has been featured in Communication Arts, Studio Photography, and Design and View Camera magazine. He has also won various awards for his photography.

www.zavesmith.com

JOHN SOARES

Boston-based photographer John Soares has been called the "King-Daddy of Inventiveness." He always tries the unexpected: shooting portraits in a bowl of milk or kicking tripods while the flash is going off. The outcome is consistently raw and emotional. His clients include Starbucks, Staples, *Fast Company, Technology Review, Communication Arts, Print,* and *Rolling Stone.* He has also won numerous awards.

www.soaresphotos.com

RICK SOUDERS

Rick Souders, a graduate of the Art Center College of Design in Pasadena, California, has been in the photography business for 17 years. His work can be seen worldwide in advertising print campaigns, outdoor billboards, magazines, annual reports, as well as on the Internet. Rick specializes in food and beverage photography, including pours, splashes and liquid-in-motion. Souders Studios is now recognized as one of the top 5 beverage studios in the country. In addition to being the recipient of numerous regional and national awards, Rick's work has been featured at the Kodak Professional Photography Pavilion at Epcot and at the International Photography Hall of Fame.

www.soudersstudios.com

IRENE SPECTOR

Specializing in outdoor and travel photography, Irene Spector brings to her work an adventure-some spirit gained through a lifetime of living and traveling around the world. Whether shooting for stock or editorial assignments, her attention to detail, acumen for research, and irrepressible curiosity distinguish her approach to any assignment. She has worked with the Smithsonian Institution Traveling Exhibition Service and the Cincinnati Art Museum. Her personal work currently includes shooting Icelandic horses in the U.S. and the tobacco industry in Maryland.

www.irenespector.com

BILL STEELE

Bill Steele is an established still-life photographer in New York City. Over the past 15 years his work has been seen in hundreds of magazines and advertising campaigns.

www.billsteelephotography.com

DEBBIE TAM

Debbie Tam graduated from the Fort Lauderdale Art Institute with an Advertising Design degree, and has spent over 20 years behind the camera. She has worked as an aerial and portrait photographer, including work on calendars. For the last seven years, she has worked with various major children's modeling agencies in south Florida. Currently, she is repositioning into advertising, graphic design, and editorial work, specializing in children.

www.debbietam.com

DAVID ULMER

David Ulmer has been a commercial photographer in St. Louis for 20+ years. In addition, his editorial work has appeared in such publications as *Natural History, Backpacker, Sierra, Outside, Canoe, American Birds, Audubon, The Missouri Conservationist, Stern, European Travel & Life* and the *St. Louis Post Dispatch.* His work appears in the book *Colorful Missouri* and he was one of 100 photographers who participated in a one-day shoot of America for the book, *Country/USA.* A photo from that project was used in a US Information Agency show at Genoa '92.

www.asmpstlouis.org/z_ulmer_david.html

FRANCO VOGT

Franco Vogt creates bold, passionate images from the familiarity of everyday. Approaching his subjects with visual clarity, a classic sense of composition, and fluid color, the viewer is compelled by his imagery. Franco balances fantasy, emotion and dynamic energy with deft humor, creating the most modern results.

www.francovogt.com

BRIAN WARLING

Brian Warling has achieved acclaim in his ability to capture the essence of a child with emotion and energy in an imaginative visual style. Brian thinks and shoots graphically with attention to color, distortion, light, styling, and focus and in this style creates memorable, iconographic images for an international clientele.

www.warlingstudios.com

ANTHONY WOOD

Anthony Wood specializes in location photography for corporations and nonprofit organizations. Currently, his focus is on fine art and editorial-style portraits. He was awarded the Golden Light Award by the Maine Photography Workshop. His work has appeared in *Photo Review* and *The Sun,* a magazine of fine art photography, among others, as well as in *10,000 Eyes,* a book celebrating the American Society of Magazine Photographers' 150th anniversary. Together with his wife Tracy, he has operated a successful photography business for 20 years. They live and work in the Philadelphia area, and have a six-year-old daughter, Amity, who is their other major focus.

www.anthonywoodphotography.com

FRANCINE ZASLOW

Boston-based Francine Zaslow makes ordinary objects appear extraordinary with her sensitivity to lighting and composition. For over a decade Francine has been running her own successful and evolving photography studio. Some current clients include Fresh, Mariposa, Gillette, Fleet Bank, Sam and Libby, Volkswagen, *Bon Appetit,* and *Gourmet Magazine.*

www.francinezaslow.com

INDEX